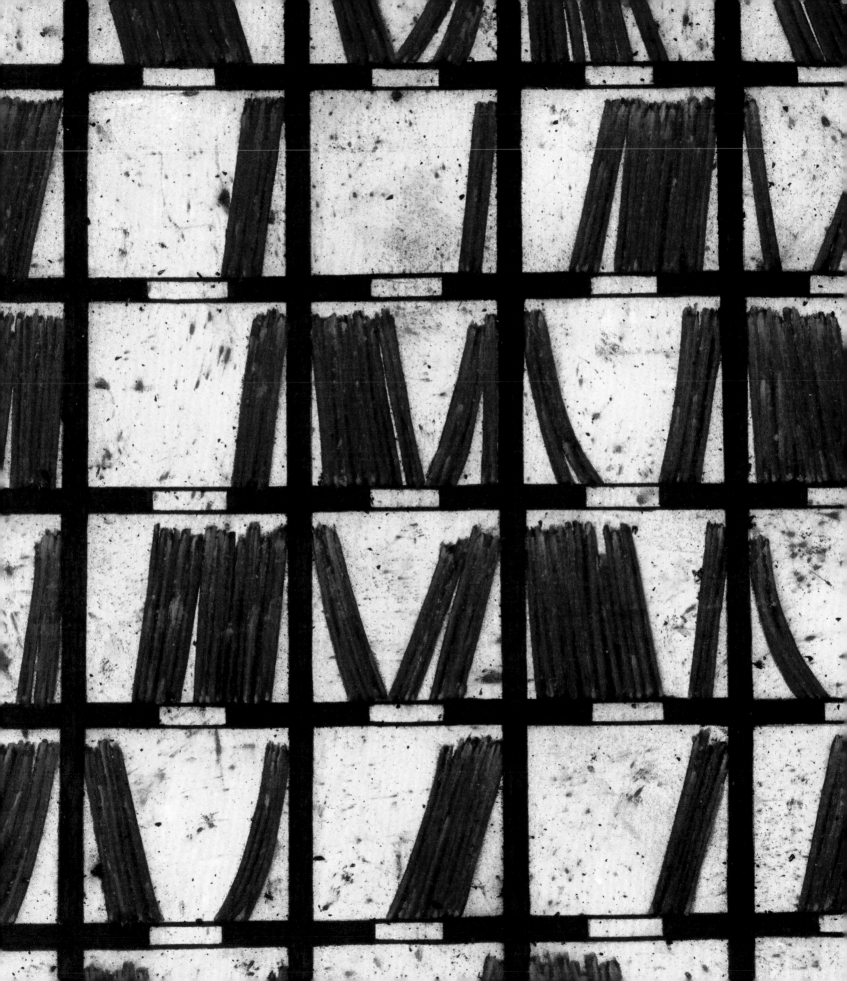

TONY BEVAN

TREES AND ARCHIVES

With Essays by Paul Moorhouse

BEN BROWN FINE ARTS

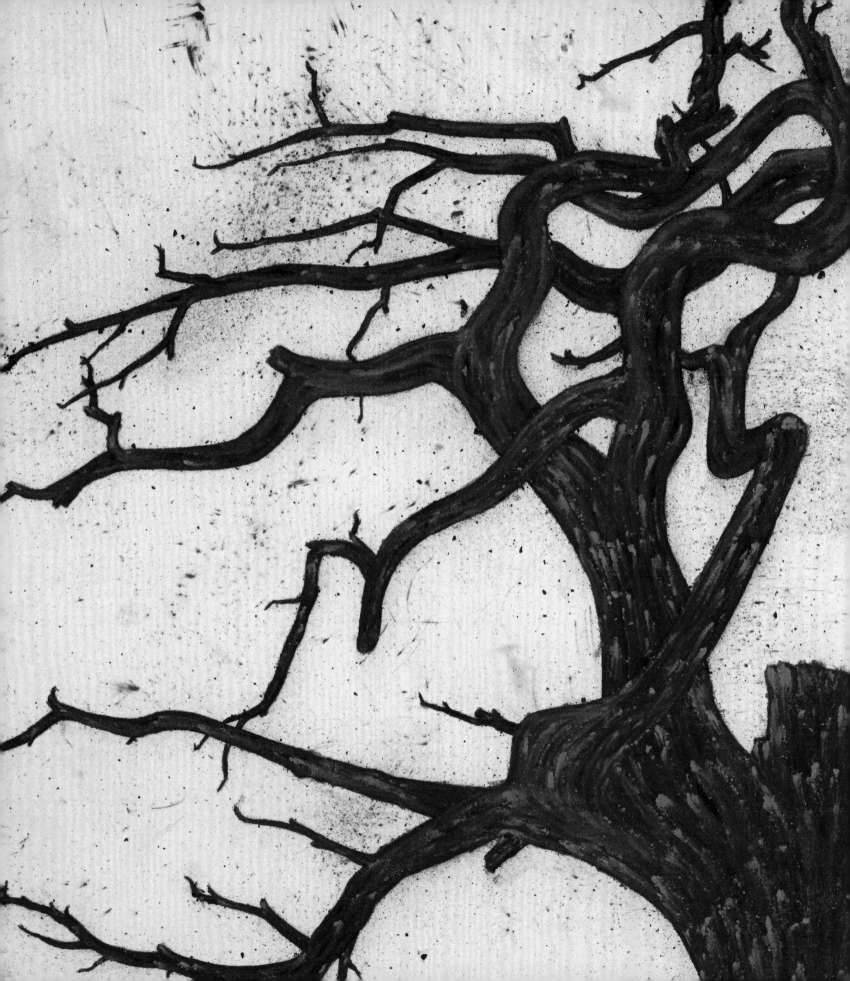

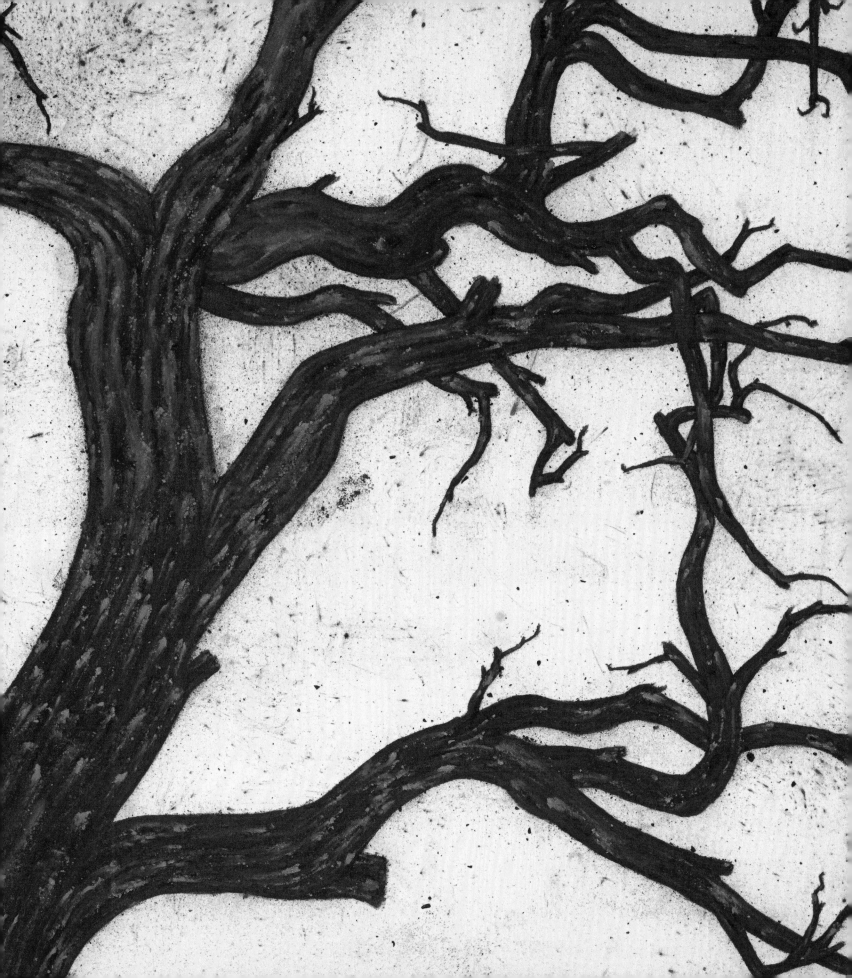

TONY BEVAN: TREES AND ARCHIVES

'*…anyone who is attentive can observe in himself, enable us to see how the intellect is such a stranger to the will…*' Arthur Schopenhauer [1]

In 2007, Tony Bevan made a drawing of a tree. At that time he was staying in China, the first of several subsequent visits, during which the vast scale and the unfamiliarity of that country's history and culture would make a deepening impression. On the occasion in question he had been wandering around a site of ancient temples, a place that he recognised as an area of 'reverie'. As visitors to these timeless shrines readily perceive, the conjunction of architecture and nature exercises an uncanny fascination. Though now disused, the man-made structures seem haunted, intimating a domain of experience that transcends the immediate and comprehensible. In that location, Bevan was struck by the unusual growth patterns formed by the surrounding trees. Devoid of leaves, their branches were twisted and gnarled, coiled and overlapping, almost writhing. He made a sketch on the spot which preserved that immediate impression.

On his return to London, he pinned the drawing to a wall in his studio where it joined several other scraps of paper preserving images, hand-written notes and traces of ideas. There it remained, and over the ensuing five years it maintained an anonymous and unassuming presence. A silent witness to his studio activity, it may even have been largely forgotten. Then, on one day in 2012 and without apparent premeditation, the drawing once more attracted his attention and, to use Bevan's own word, it 'ignited' [2]. While the image remained true to the motif he had observed, it seemed that in the interim his response to the original experience had, without his conscious awareness, undergone some kind of imaginative development. As if emerging from the peripheries of vision, the tree's appearance, structure and presence now appeared afresh. While preserving its initial strangeness, it now seemed replete with potential. The drawing became the starting point and the basis for a new body of work. Focused on the tree format, the resulting series comprises fifteen paintings and a similar number of related, large-scale drawings.

Developing beyond the sketch made in situ, in the paintings and drawings there is a powerful sense of something rooted in observation, yet now reaching towards other areas of experience. The tree is both recognisable and familiar, but Bevan's treatment of the motif has subjected the initial

pattern of natural, dendritic growth to a process of rigorous abstraction. Viewing the series as a whole, it is apparent that the respective works have each been drained of naturalistic colour. Re-imagined in a visceral cadmium red, a rust-like orange and a rich, saturated purple, there is a resulting emphasis on the emotive message conveyed by these colours, but also an insistent emphasis on the formal character of each image. Drawn first in charcoal and then overlaid and reinforced with paint, an expanding network of marks preserves a trace of the artist's movements through a virtual space.

The structures' main tributary, the trunk, provides a conduit for the main flow of energy. Proceeding outwards from that main shaft, each branch carries an expressive significance as it probes its surroundings, sometimes tentatively and on occasion with a nervous, imperative urgency. The resulting pattern is organic and alive, but not simply tree-like. From a description of branches there emerges an impression of tangled limbs, entwined elbows and knees. A natural form yields a sense of individual life: an implication connected not only with the intimation of figures but also, in a more abstract way, with a sense of direction. The path taken through life, with its advances, excursions, explorations and meanderings, finds an echo in these strange organic maps of intention and frustrated momentum. The peculiar force of these paintings and drawings derives, not least, from this act of transformation: the artist inhabiting a structure and, in so doing, investing it with qualities that seem irresistibly human.

Central to that impression is the intimation, which Bevan's work conveys so directly, of something physical and visceral. The materials he uses – charcoal, pigment and paint – have a sensuous appeal which feeds the eye. But his work also has a tangible and irresistible facture. The raw canvas bears the evidence of his activity and movements in bruise-like stains, and the explosive shattering of the charcoal stick or the trace of a loaded brush. Each of these interventions provides a trace of the hand and gesture that directed the process. But beyond that, and caught up in each image, there is a more intangible presence: that of the thought processes at work. Ghostly marks suggest revisions and changes of mind. But also, as if trapped within a net of contradictions, the spaces formed by overlapping branches seem forever on the verge of assuming a recognisable form. The trees are in this respect mysterious and unsettling: elemental and physical, they are nevertheless structures inhabited by elusive images at the edge of our awareness.

This equation of the physical and the cognitive extends concerns present in Bevan's art since its beginnings, and in the *Tree* and the more recent *Archive* series this remains a preoccupation. Whether based on found photographs or observation of his own image, his work has always explored the capacity of certain motifs to provide a site for imaginative exploration. From the early paintings of the human figure and self portraits to images of the human head, corridors, towers and objects strewn on tables and, currently, to tree structures and repositories of archival information, he has tapped a rich reservoir of subjective association. Each of these motifs has been subjected to prolonged visual

interrogation which, in turn, has yielded an unforeseen response. Such has been the intensity of that enquiry that Bevan's subject may be said to be the imaginative domain that lies beyond the appearance of ordinary things, to which such familiar motifs are simply an entrance and a pathway. Over the course of that career, which now covers almost thirty five years, Bevan's trajectory has increasingly concentrated not only on mining his own engagement with particular themes but, in particular, on exploring the nature of the mind itself and its mysterious relationship with the body.

In that respect, the paintings and drawings of trees have a further layer of connotation. Their organic, meandering patterns resemble patterns of growth in nature but also have a biological significance. While an obvious connection can be made with arterial structures in the body itself, a further link can be made with the neural network that comprises the human nervous system. Like trees, neurons take the form of extended, dendritic pathways and they facilitate connections betweens cells. Viewed in this way, Bevan's trees can be seen as metaphors for the brain. It is as if the heads depicted in his earlier works have been reduced to their irreducible essence, forming a complex pattern of neural growth.

For scientists and philosophers the question of how a physical organ accommodates an immaterial event – a thought – has always been, and remains, mysterious. In the 19th century, the great German thinker Arthur Schopenhauer expressed that situation concisely:

> '*we are justified in asserting that the whole of the objective world, so boundless in space, so infinite in time, so unfathomable in its perfection, is really only a certain movement or affection of the pulpy mass in the skull. We ask then in astonishment what this brain is, whose function produces such a phenomenon of all phenomena.*'[3]

The sense of wonder that illuminates Schopenhauer's words lives on in Bevan's art. Neither a scientist nor a philosopher, he seeks neither to describe nor to explain. As an artist, however, he uses visual metaphor in potent ways in order to evoke the enigma of the mind.

In the *Tree* series, a biological pattern seems inhabited by ideas. In the *Archive* paintings and drawings a cell-like construction accommodates information. In both cases, the immaterial inhabits a physical structure. Based on a found photograph of an unidentified archive, the related series that he developed adopted a geometric grid format. As if stored within a compartmentalised shelf arrangement, ambiguous shapes suggest files ordered in an irregular sequence. The nature of the data they contain is undisclosed and, indeed, the label beneath each group of files has been left blank. Whether this archive is medical, financial, civic, personal, military or even sexual is a matter for conjecture. In our present information-dominated era, Bevan's archive seems like a relic of some

earlier police state. Whatever its nature, implicit in the presentation of this cryptic, hidden repository of facts is a sense only of limitlessness. The grid proceeds beyond the edges of the picture space, and the converging lines, within what seems, at first, to be an entirely regular structure, suggest a subtle perspectival recession. Clouds of fragmented charcoal resemble remote stars in distant galaxies. Evidently this is a structure that could extend indefinitely.

At that point, a connection may be made between the *Tree* and the *Archive* series. Both employ a structuring principle, one organic and the other geometric, within which the evidence of thought is implied. In their different ways, both recall a cognitive space and, in each, its manifestations are elusive or concealed. The mind is evoked, its functions and contents shrouded in mystery. As Schopenhauer observed, '[the intellect]…is a confidant that does not get to know everything.'[4] Those archives of mental experience which occupy the depths of our being, and indeed define us, are essentially unfathomable and unknowable – at least to the conscious mind. In a similar vein, the poet A E Housman noted that there are levels of experience 'obscure and latent…older than the present organisation of [man's] nature'[5] which lie beyond the intellect, accessible only to intuition. Bevan's art provides us with a tantalising glimpse.

Paul Moorhouse

1 *The World as Will and Representation*, Volume II, translated by E F J Payne, Dover Publications, 1966, p. 210
2 Conversation between the artist and the author, 17 October 2014
3 Schopenhauer, p. 273
4 Schopenhauer, p. 210
5 *The Name and Nature of Poetry*, Cambridge University Press 1945, p. 46

10　*Tree No. 2*, 2012, acrylic and charcoal on canvas, 239 × 331 cm

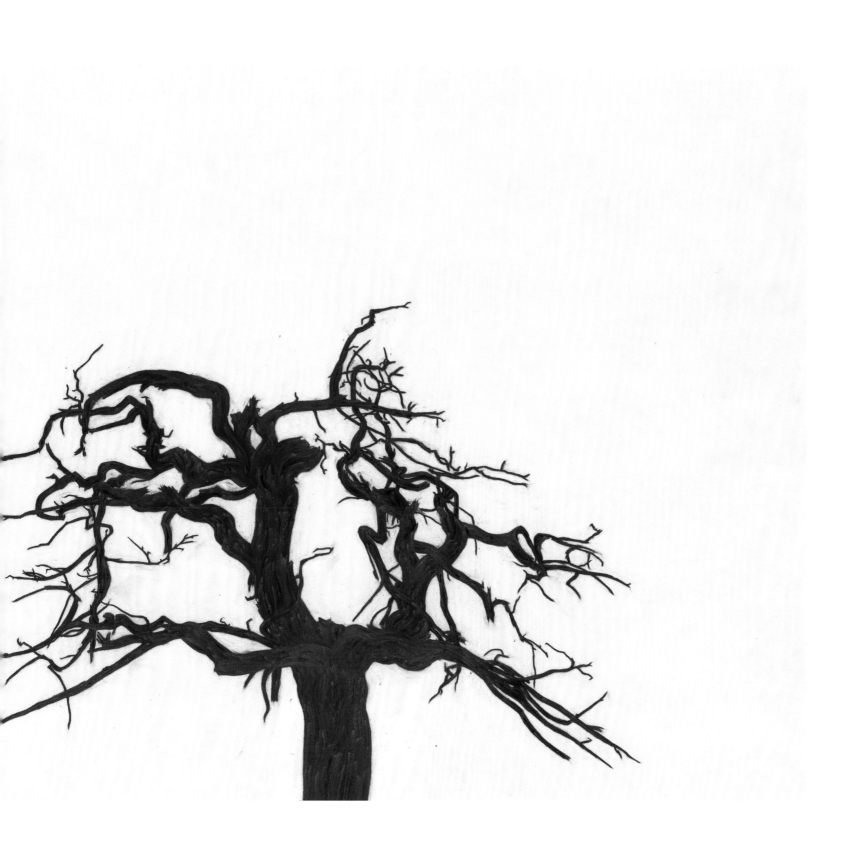

12 *Tree No. 3*, 2012, acrylic and charcoal on canvas, 137 × 232 cm

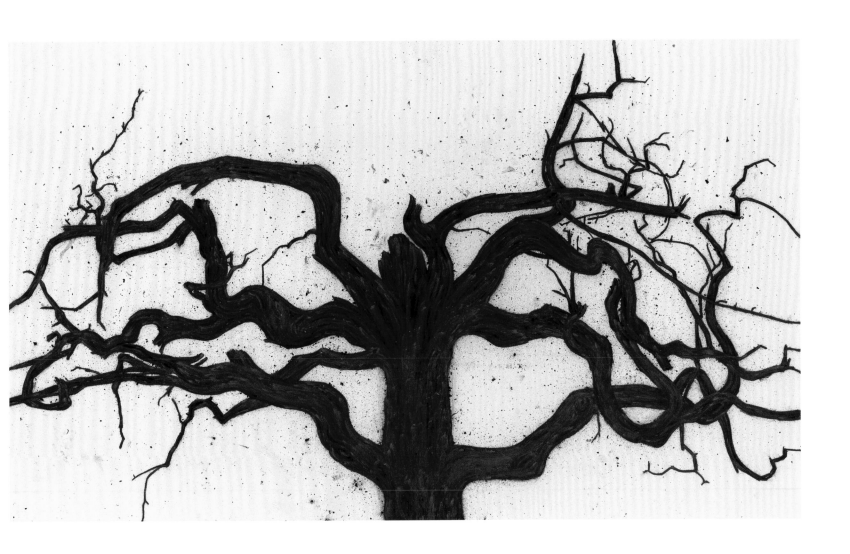

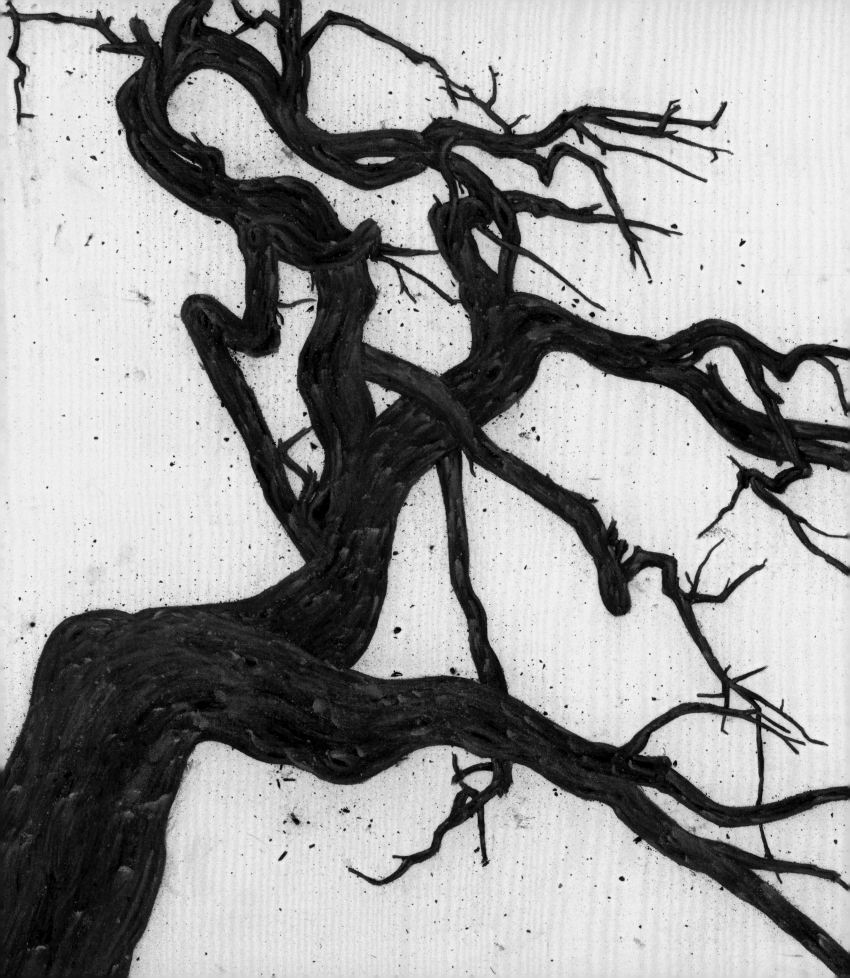

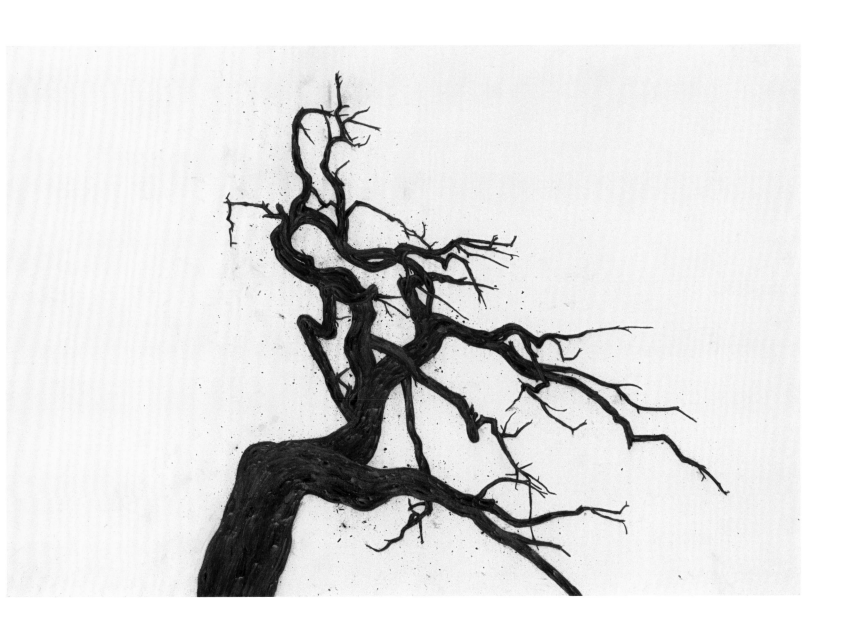

Tree No. 7, 2012, acrylic and charcoal on canvas, 166 × 240 cm

16 *Archive*, 2013, acrylic and charcoal on canvas, 158 × 140 cm

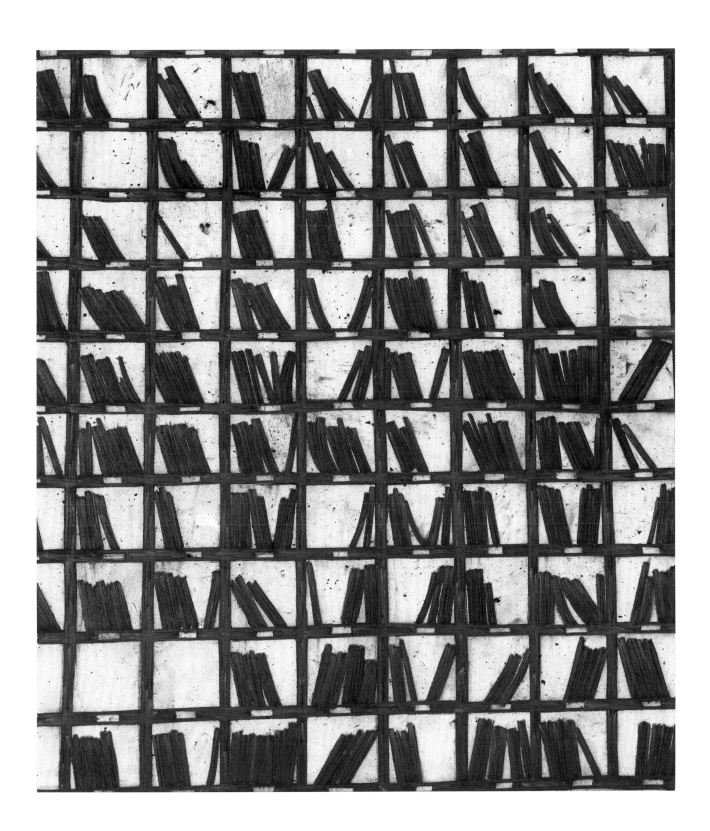

18 *Tree No.11*, 2013, acrylic and charcoal on canvas, 166 × 206 cm

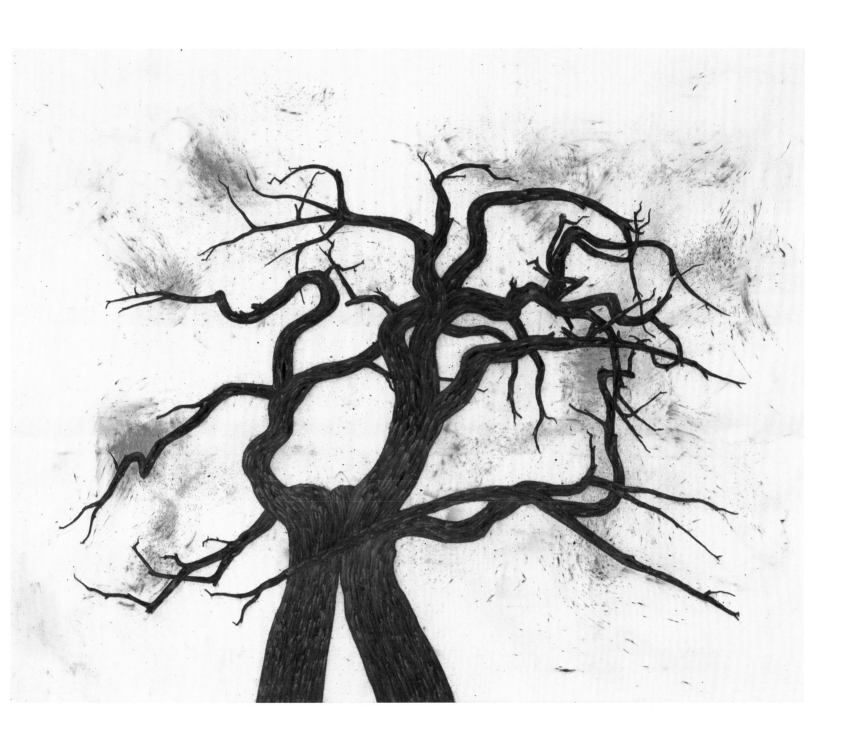

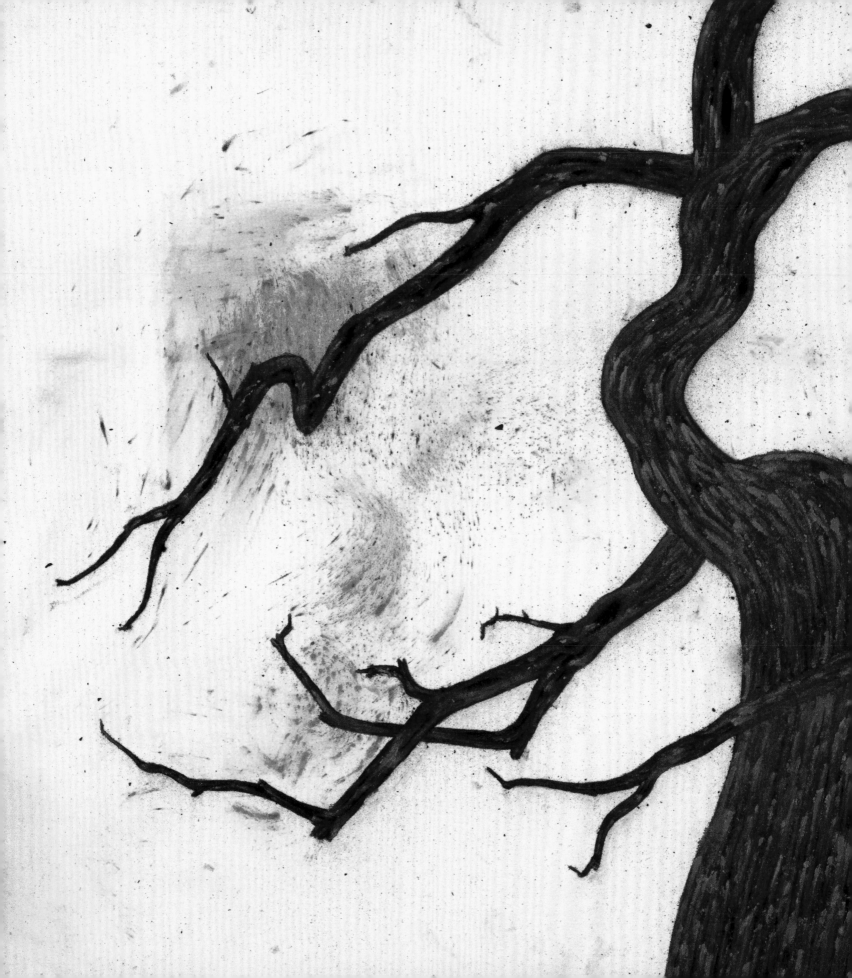

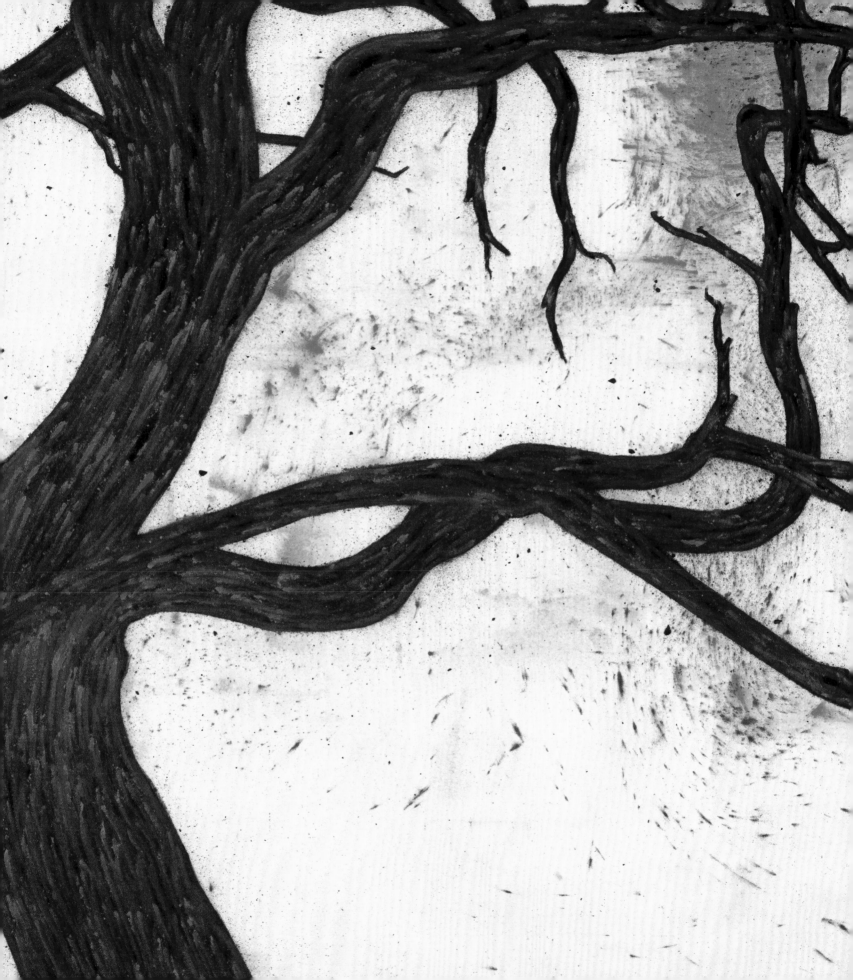

Self Portrait Skull, 2013, acrylic and charcoal on canvas, 45 × 39 cm

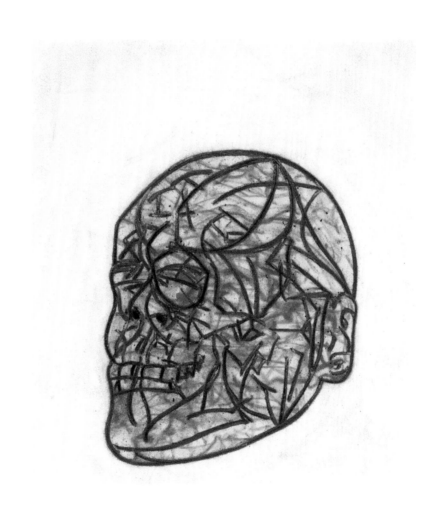

Archive, 2014, acrylic and charcoal on canvas, 164 × 157 cm

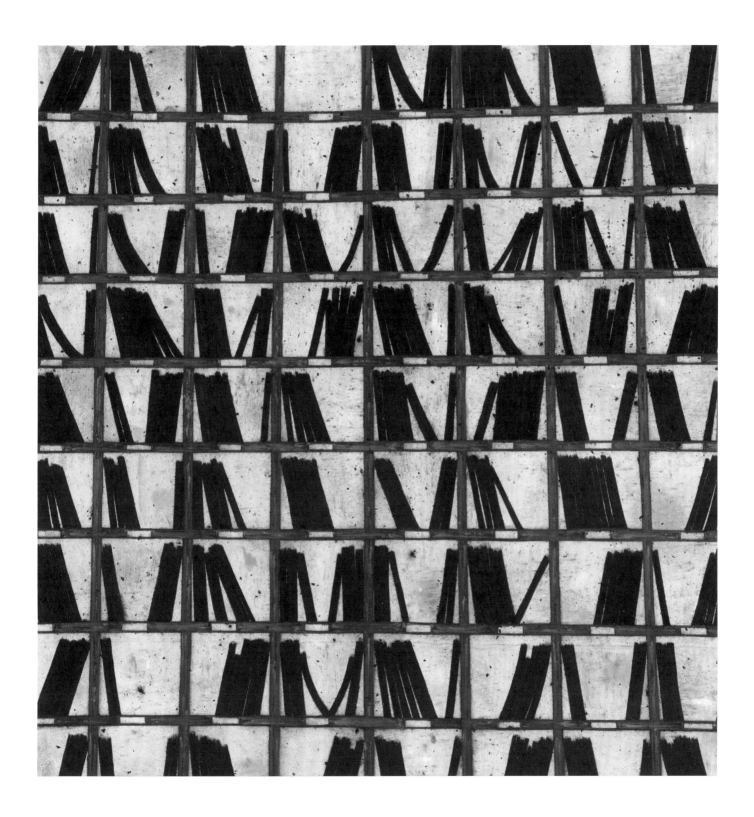

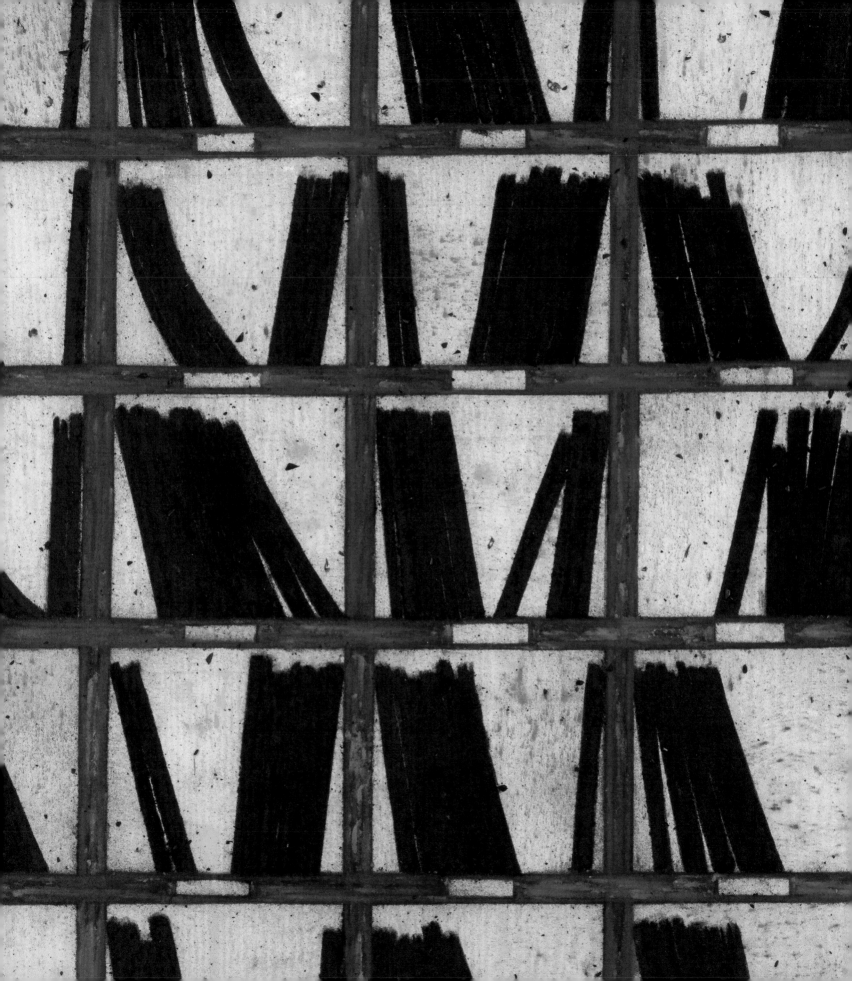

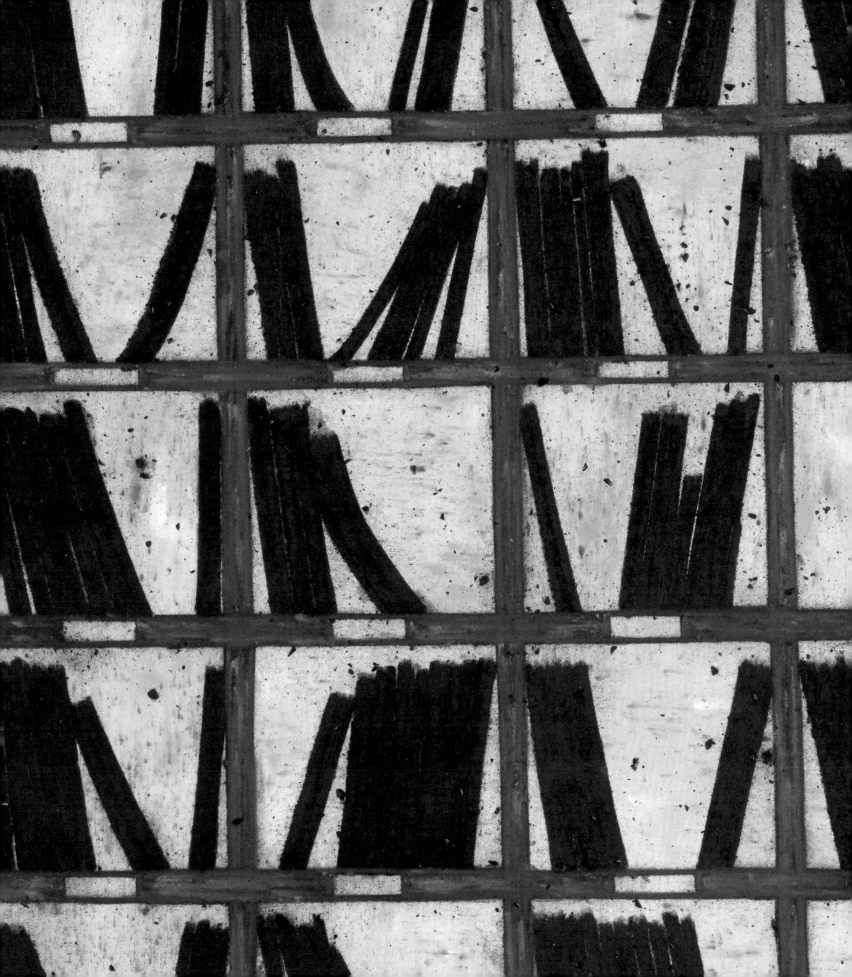

28 *Archive*, 2014, acrylic and charcoal on canvas, 192 × 155 cm

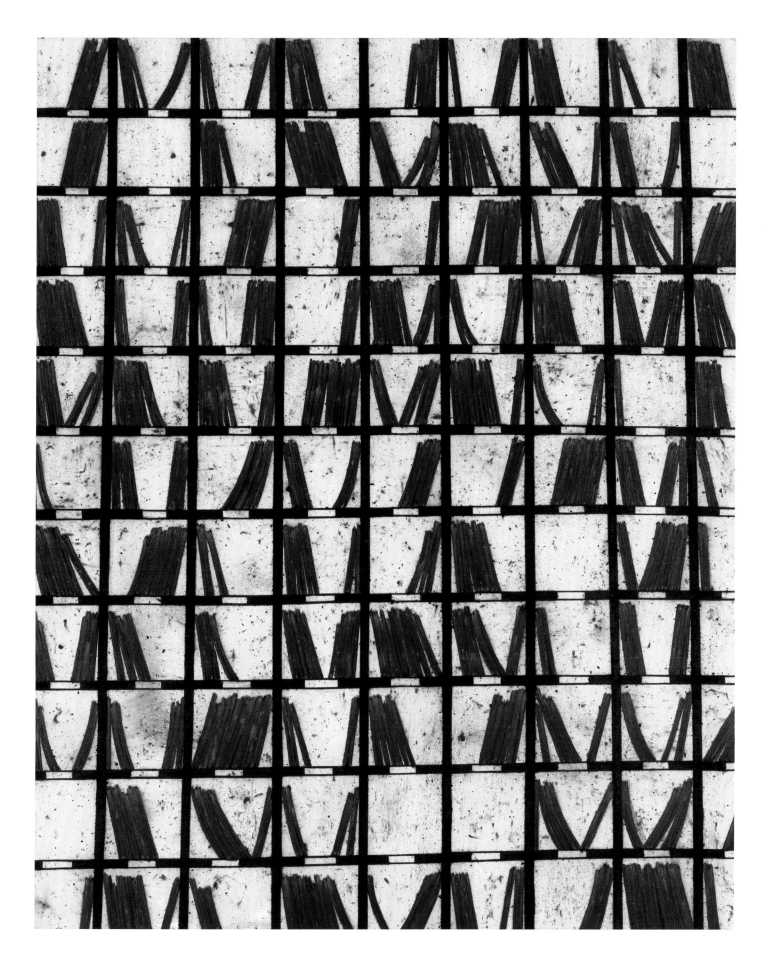

Archive, 2014, acrylic and charcoal on canvas, 194 × 166 cm

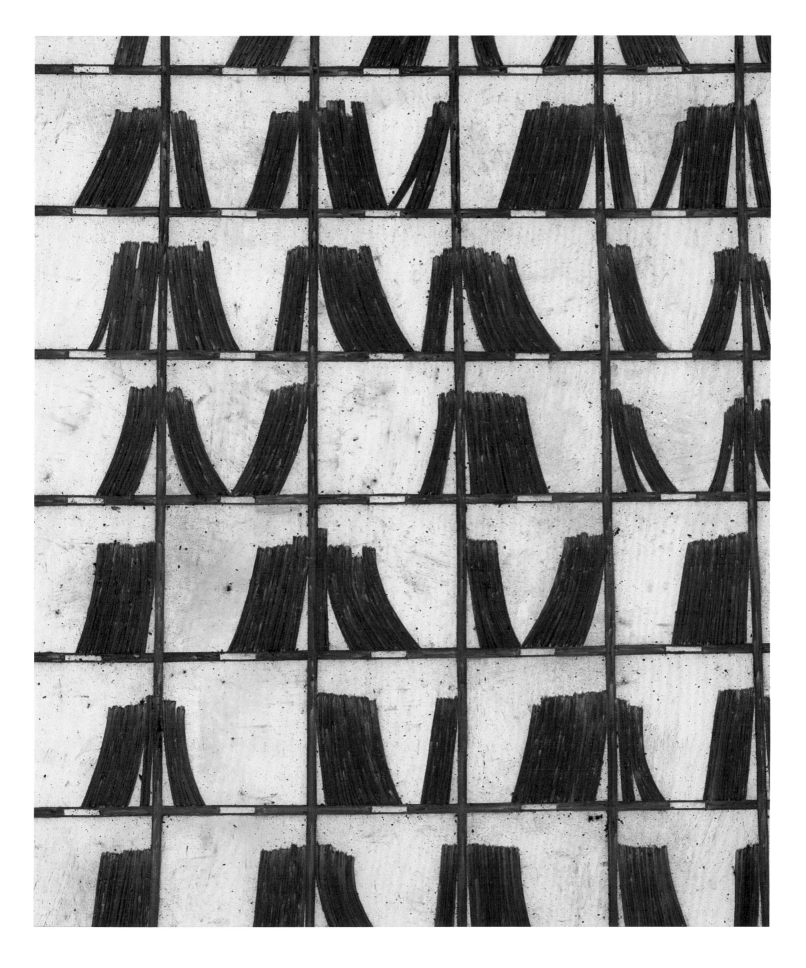

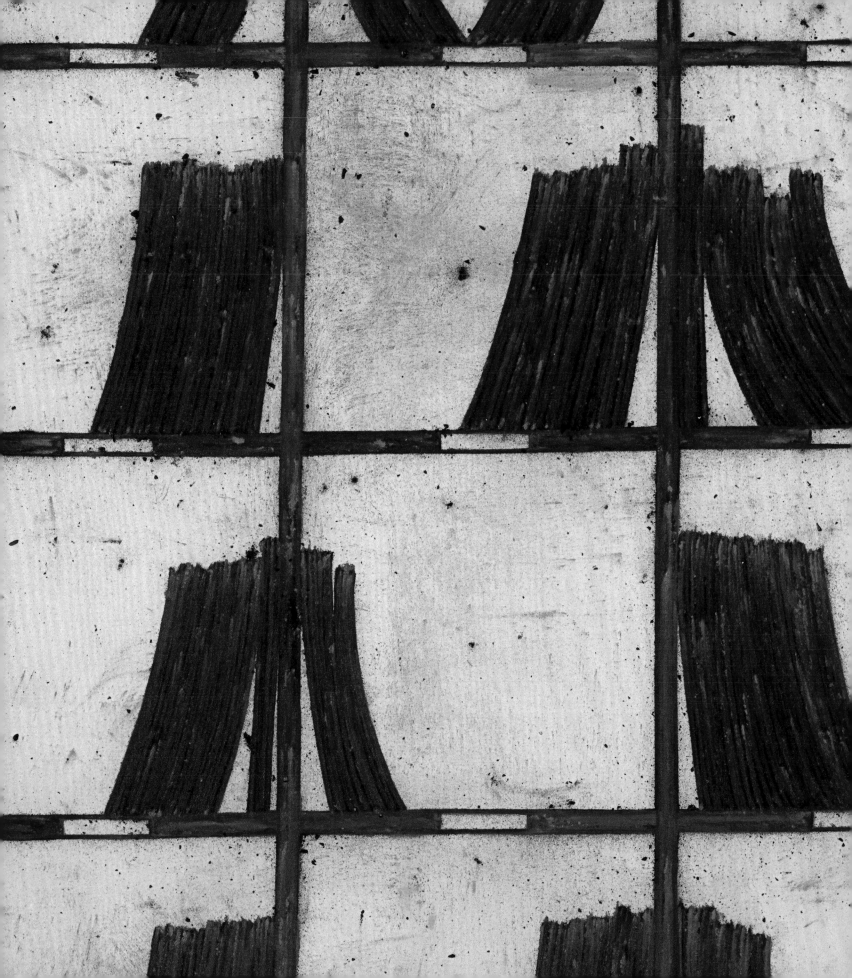

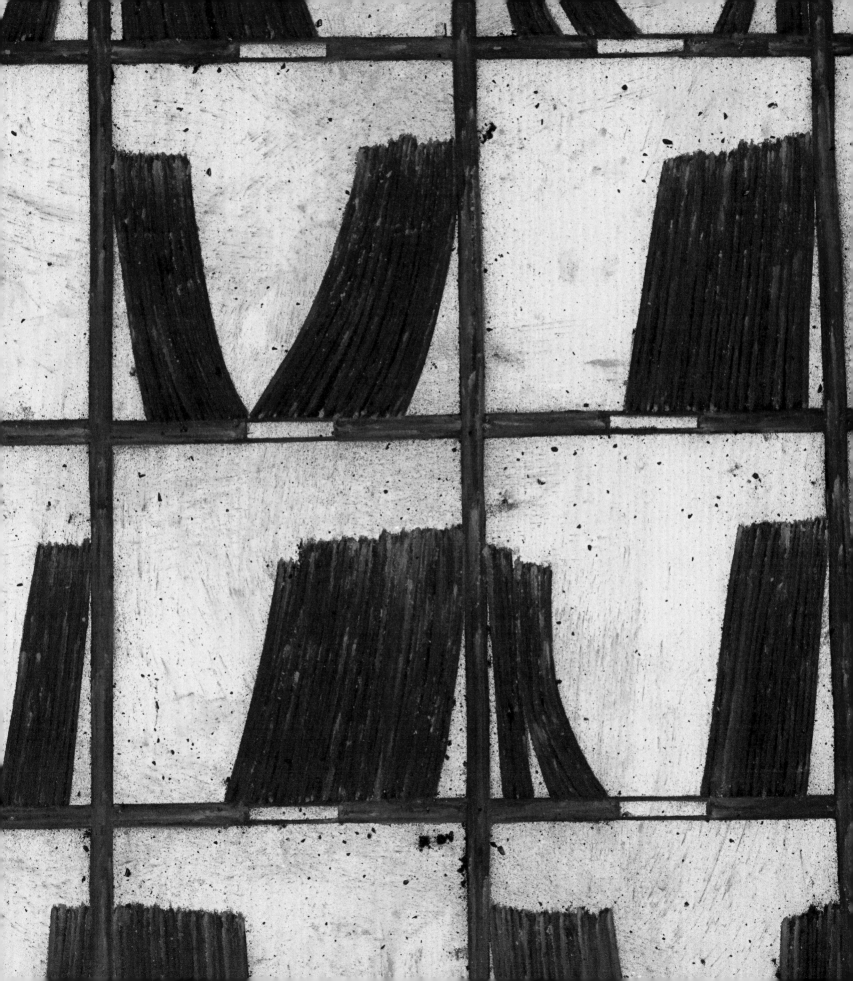

34 *Tree No.12*, 2014, acrylic and charcoal on canvas, 168 × 254 cm

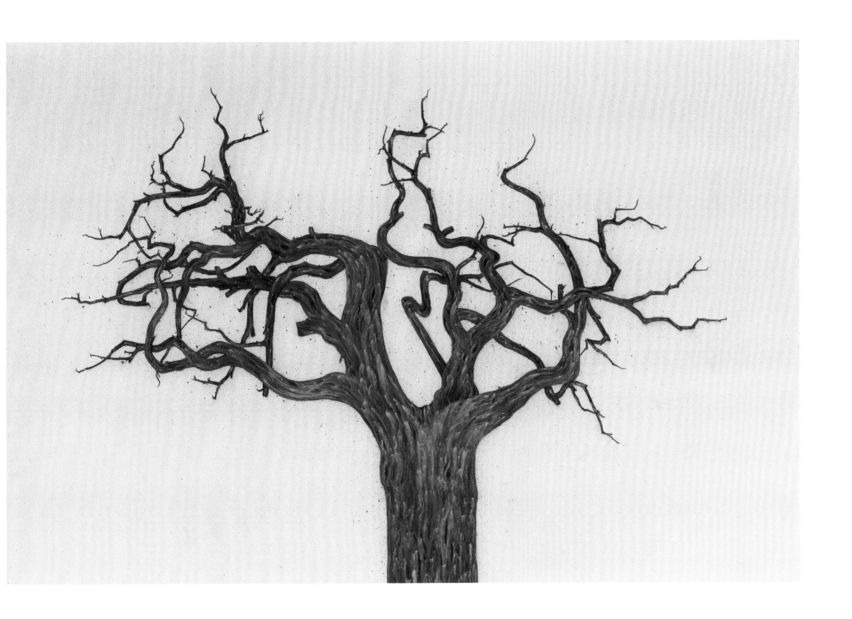

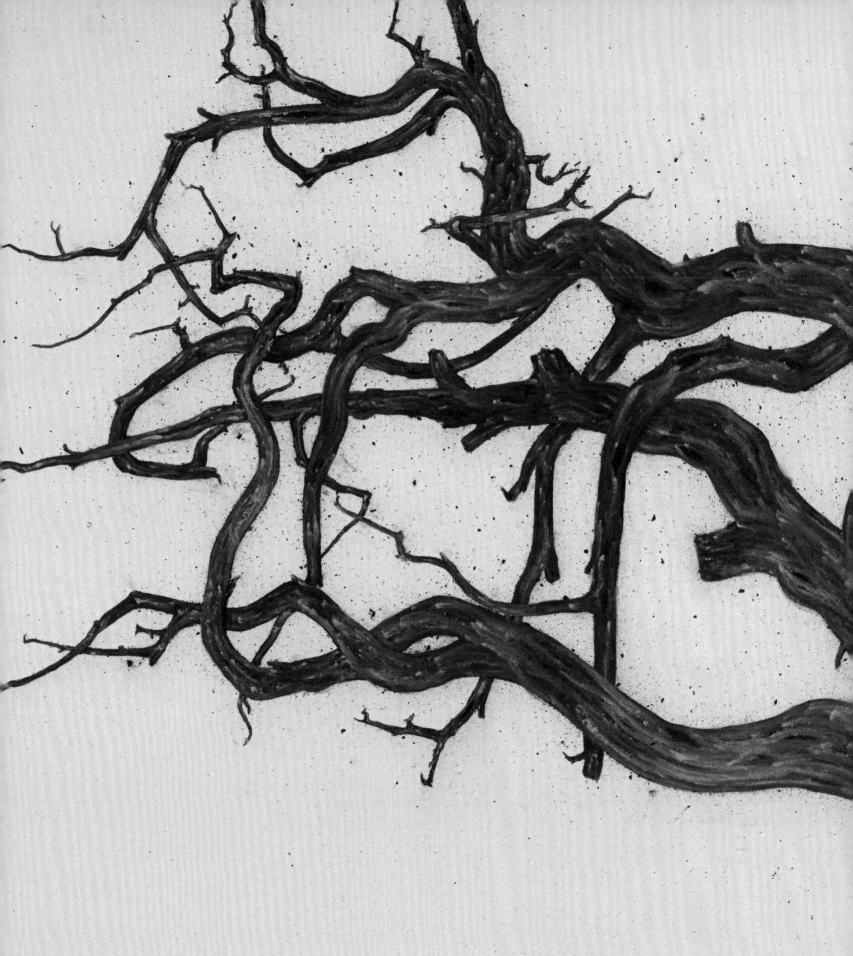

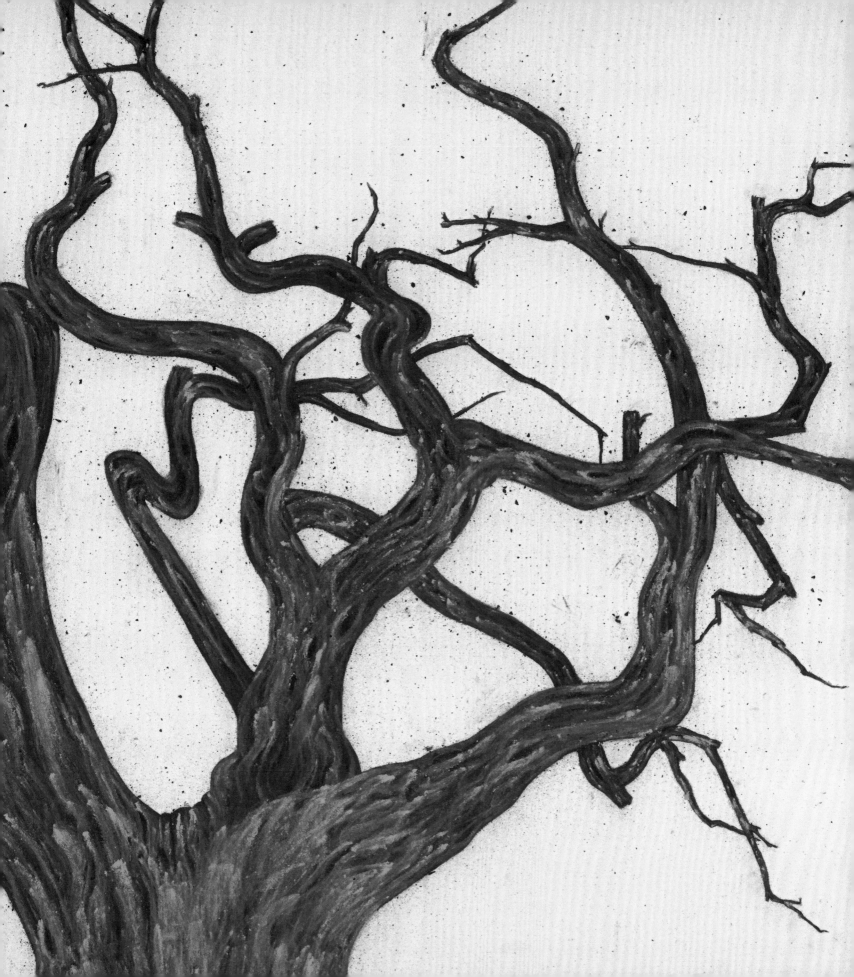

Tree No.13, 2014, acrylic and charcoal on canvas, 140 × 184 cm

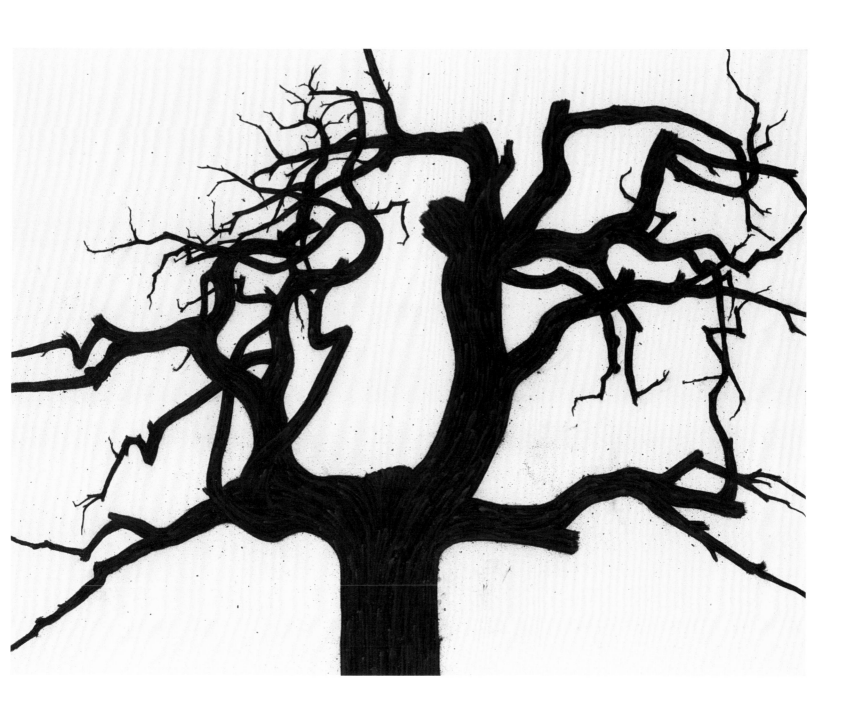

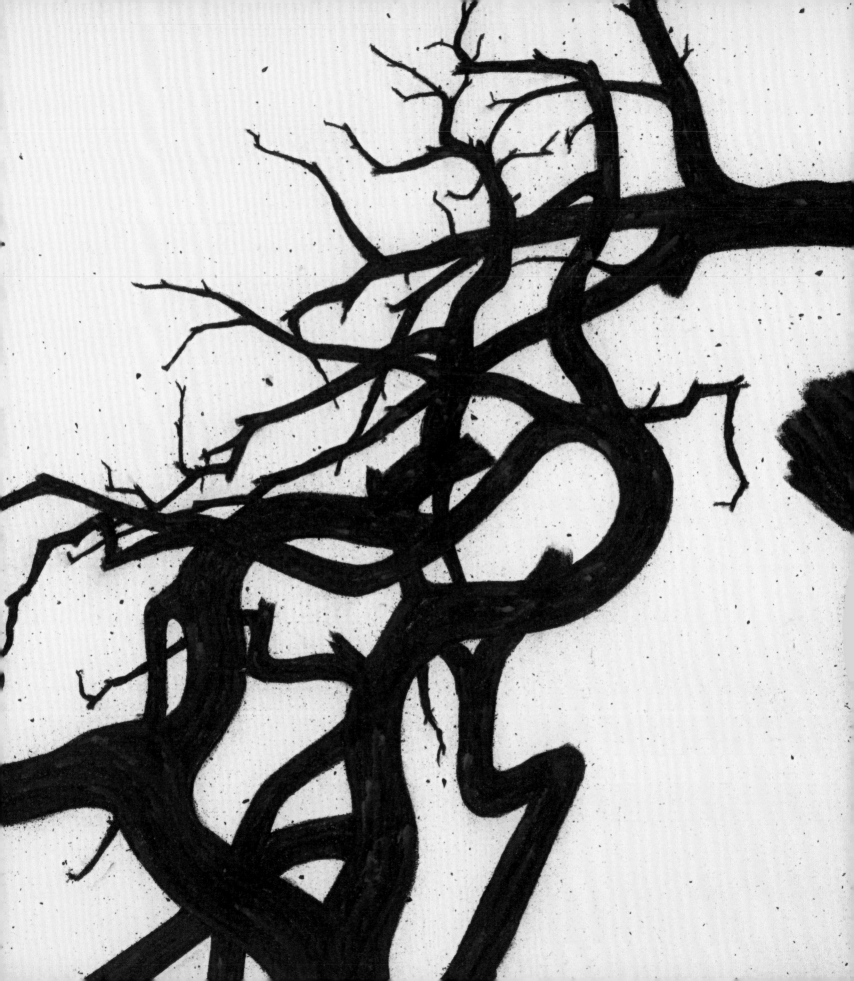

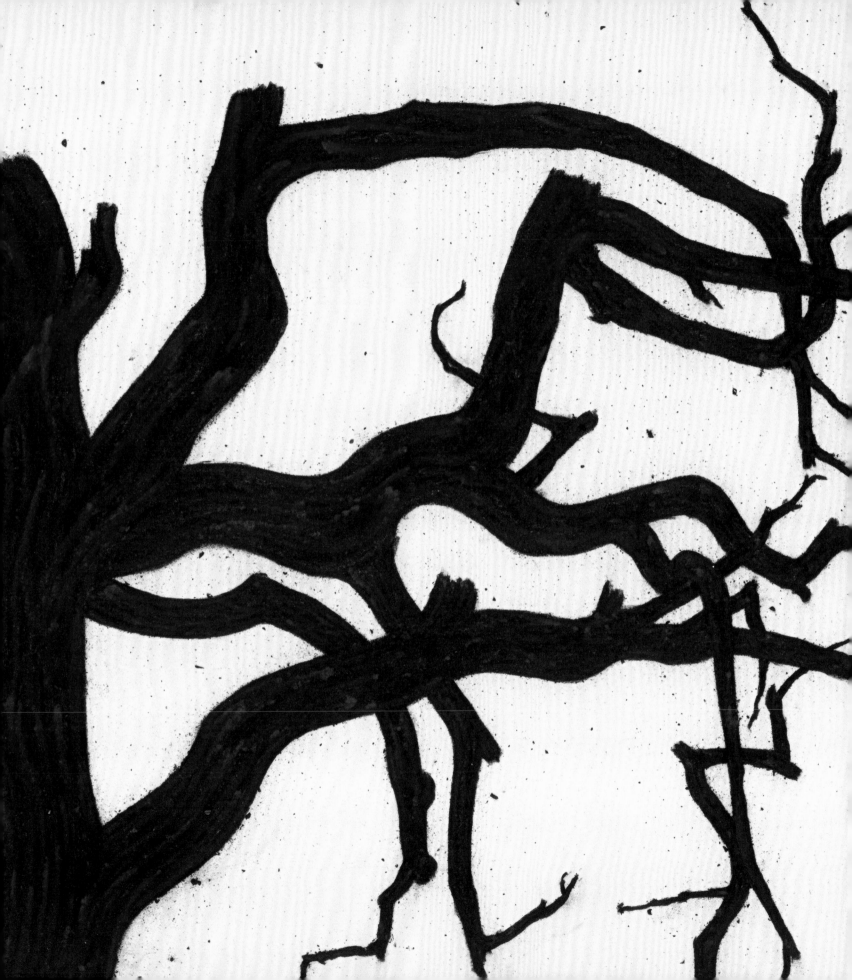

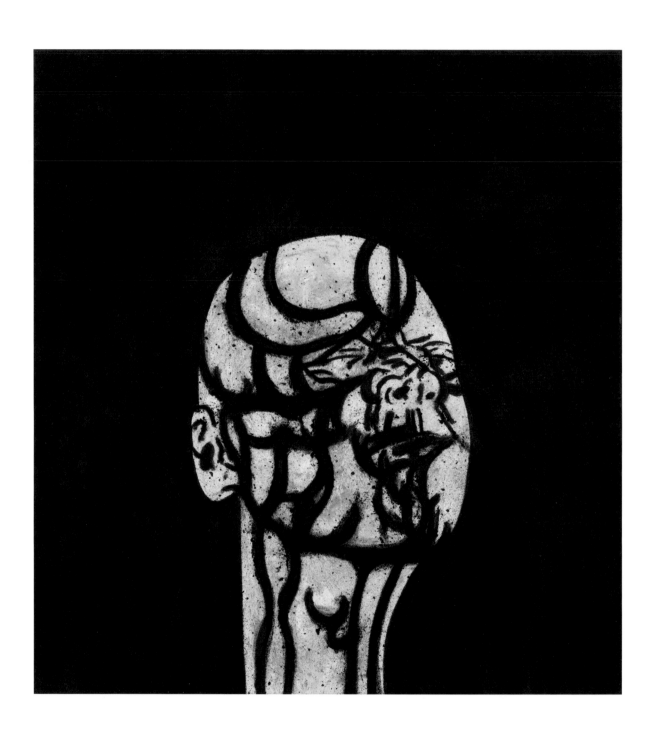

42 *Self Portrait*, 2014, acrylic and charcoal on canvas, 82 × 77 cm

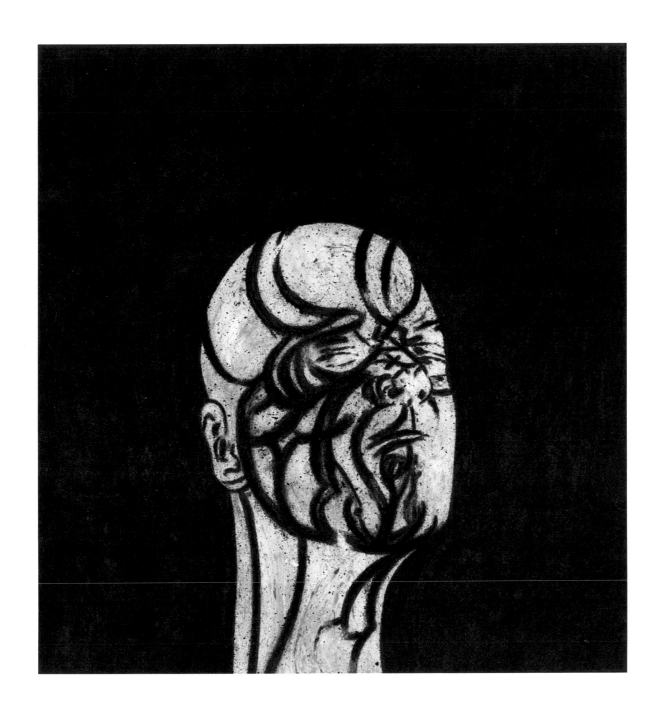

Self Portrait, 2014, acrylic and charcoal on canvas, 81×78 cm

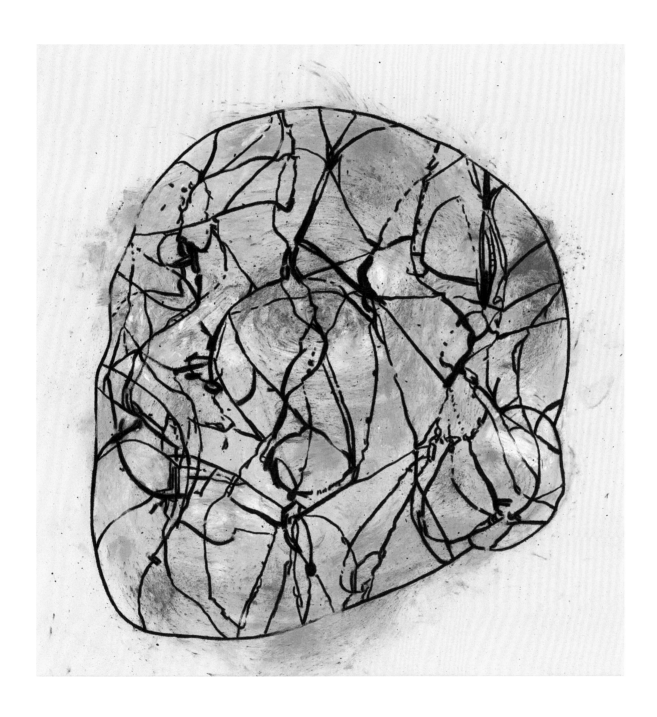

Tree No. 14, 2014, acrylic and charcoal on canvas, 155 × 206 cm

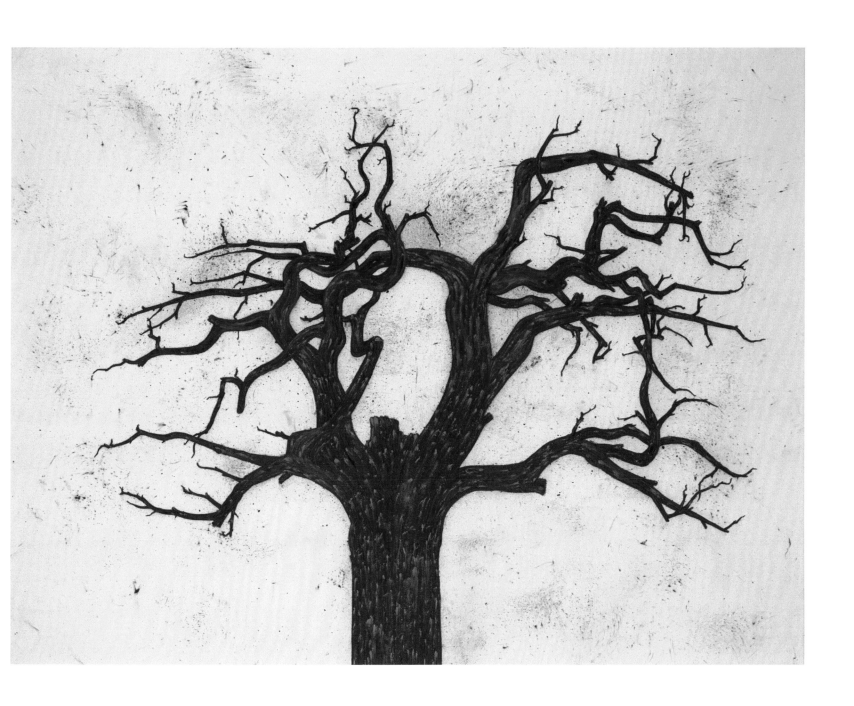

48 *Archive*, 2014, acrylic and charcoal on canvas, 185 × 161 cm

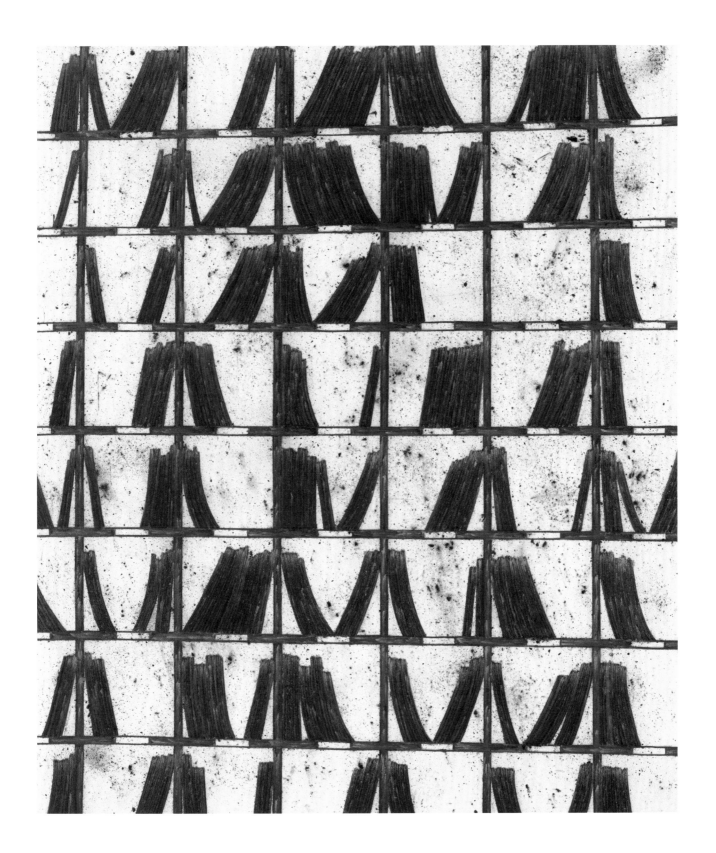

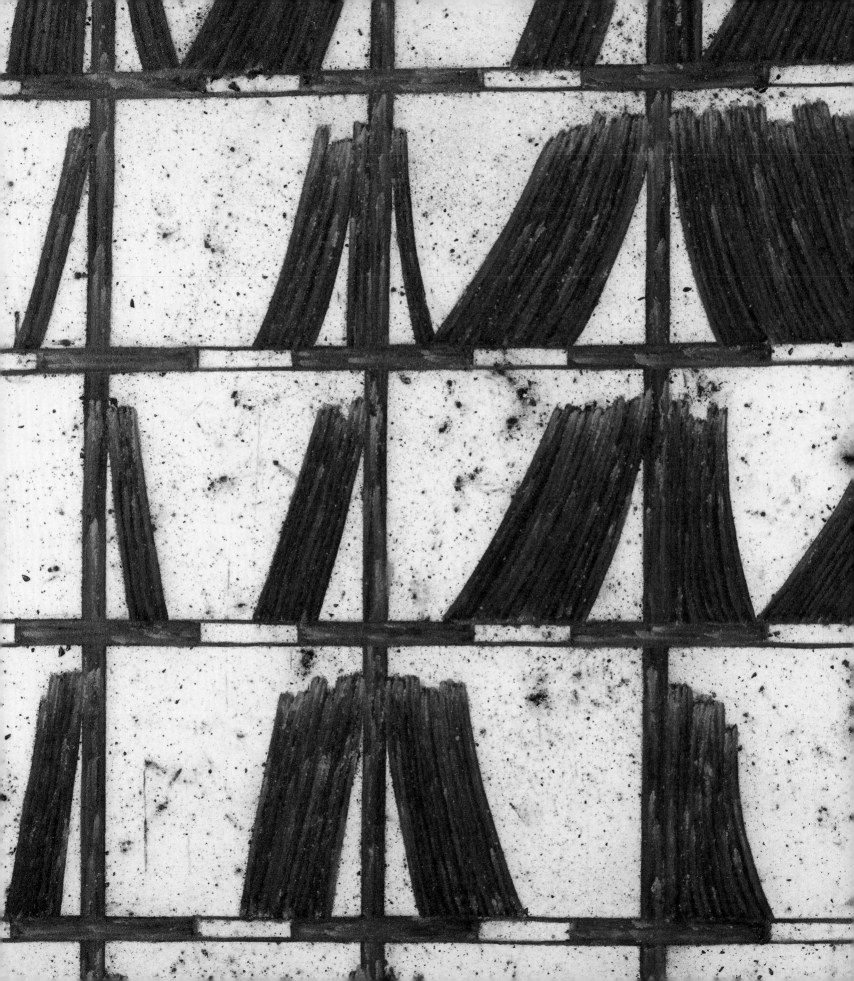

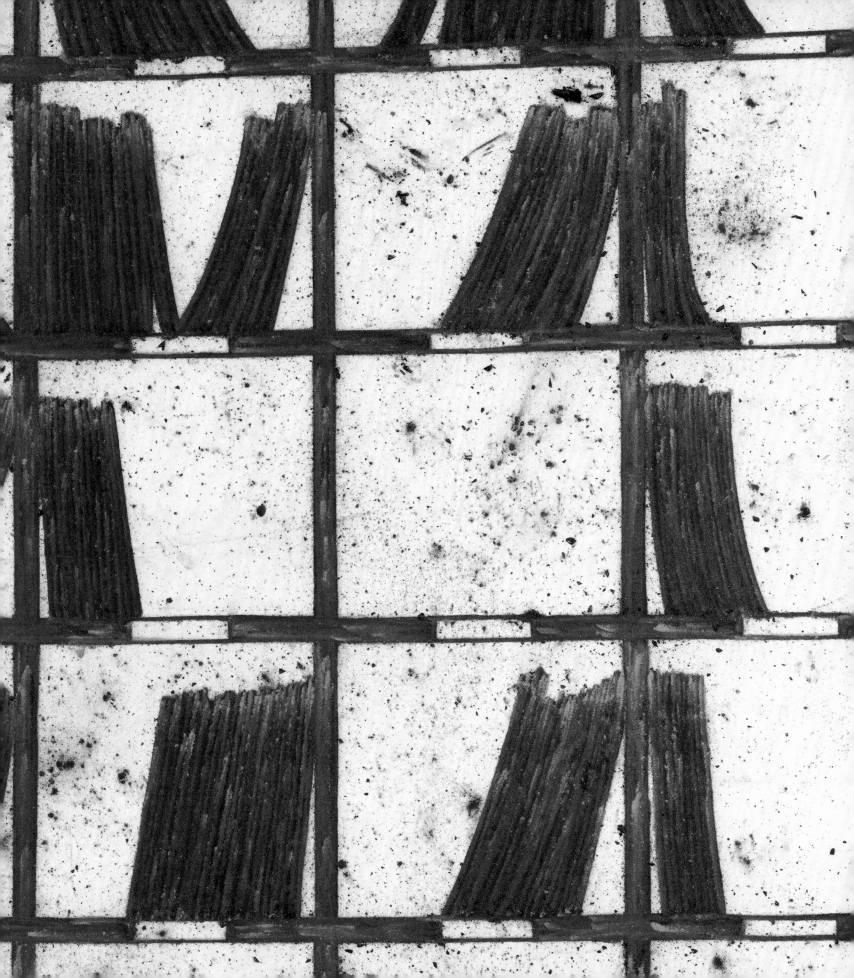

Tree No. 15, 2014, acrylic and charcoal on canvas, 163 × 212 cm

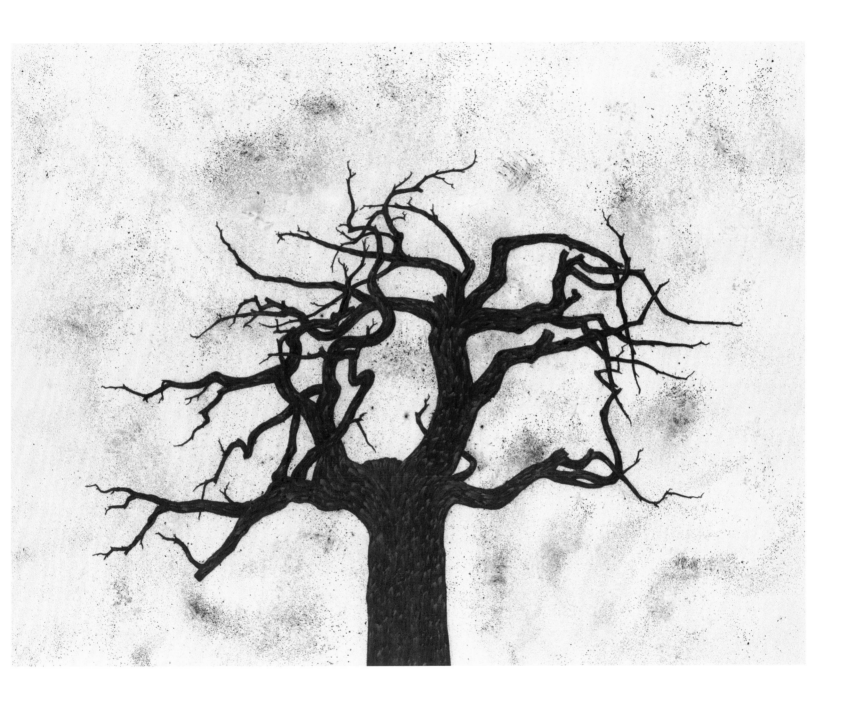

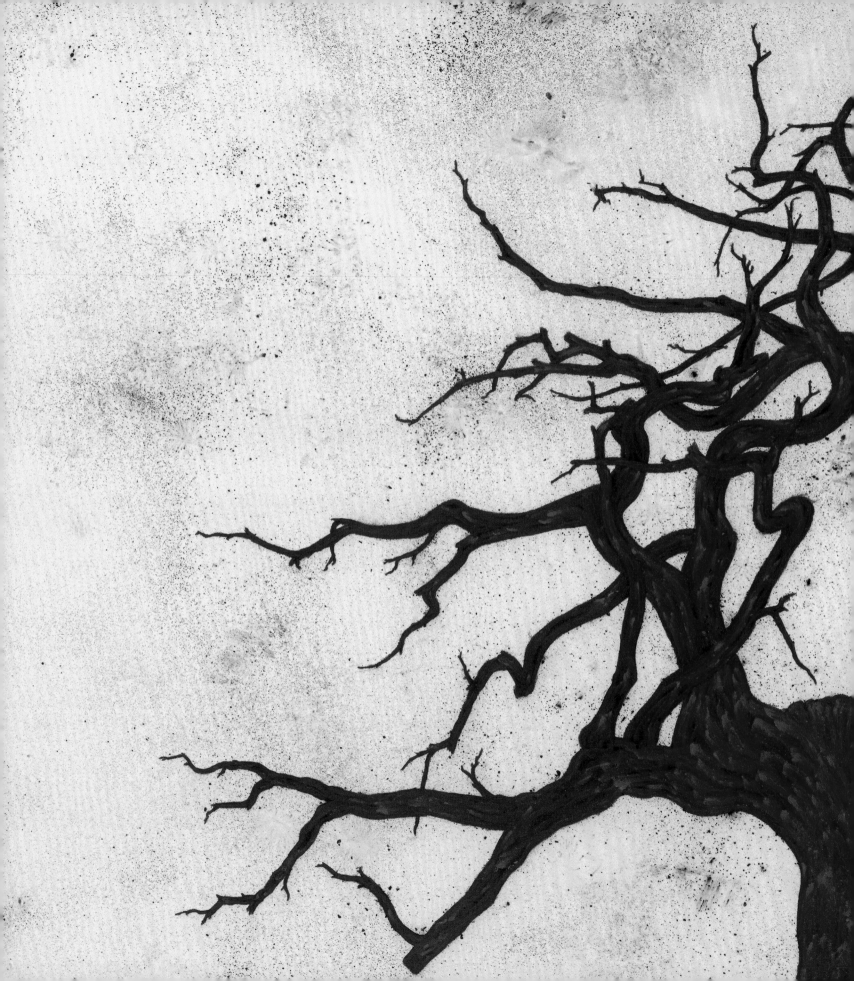

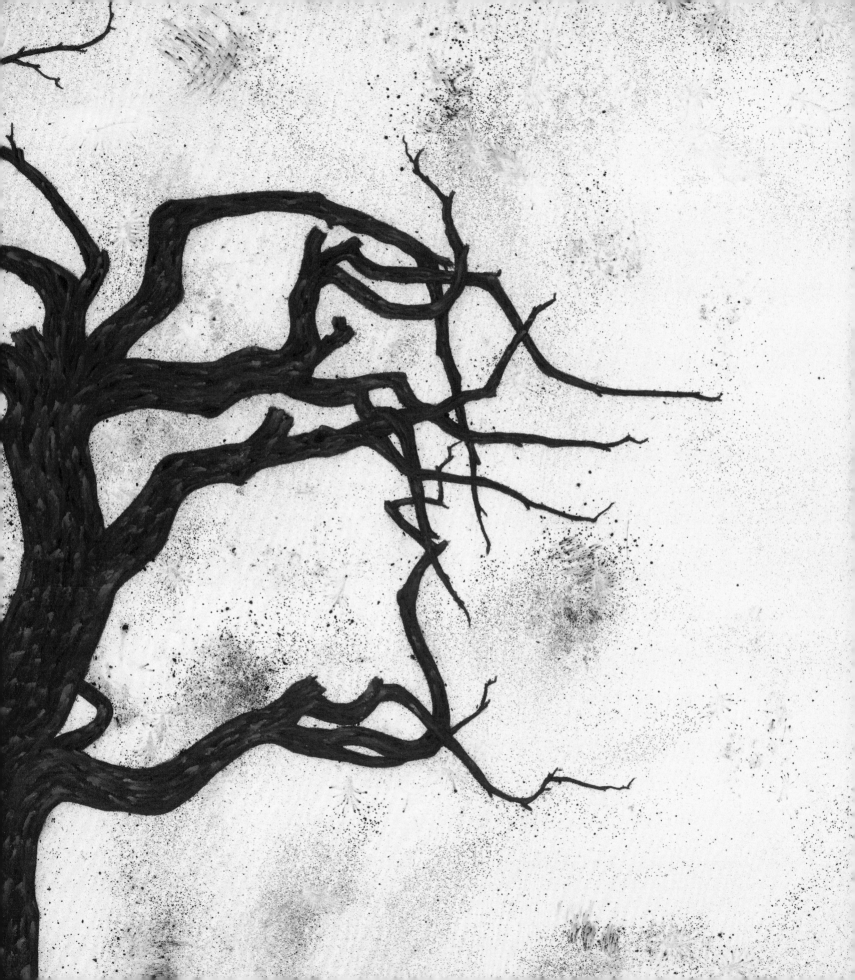

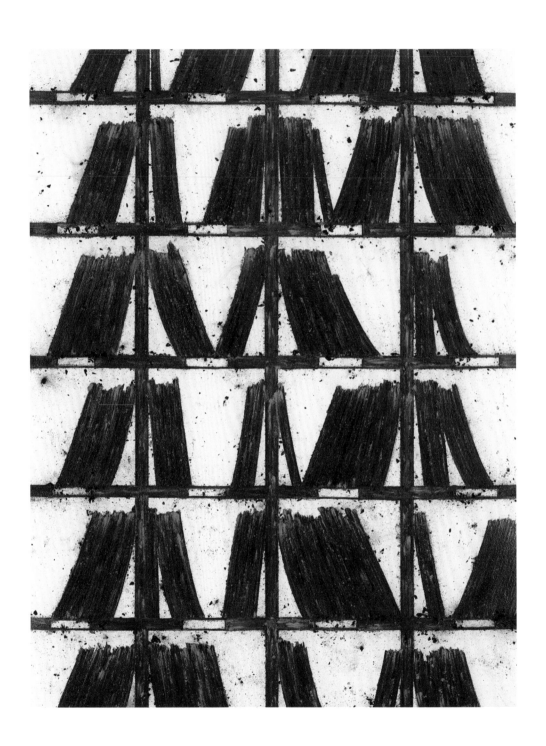

56 *Archive*, 2014, acrylic and charcoal on paper, 103 × 78 cm

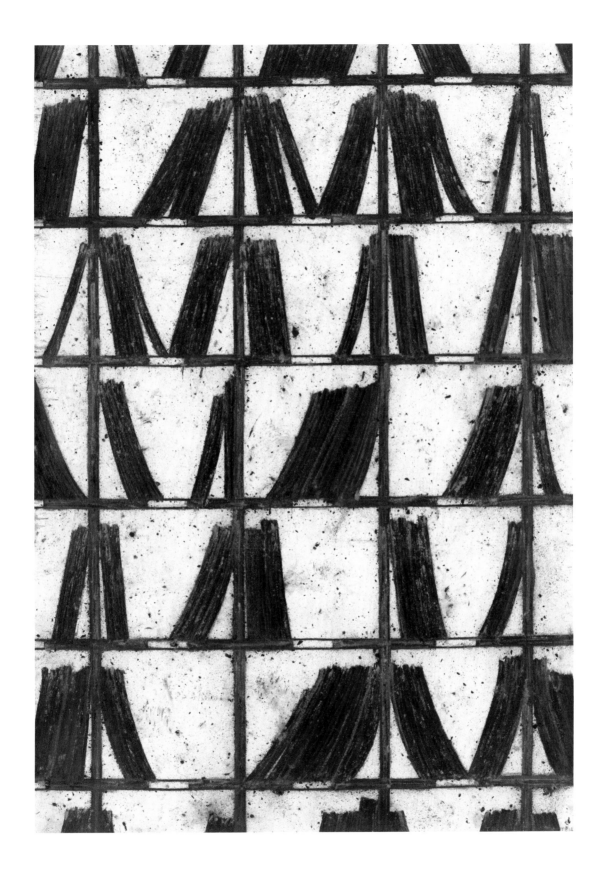

Archive, 2014, acrylic and charcoal on paper, 122 × 86 cm

THE ART OF TONY BEVAN: A THING OF THE MIND

Towards the end of Marcel Proust's vast novel, *In Search of Lost Time*[1], the narrator observes, 'How could the literature of description possibly have any value when it is only beneath the surface of the little things which such a literature describes that reality has its hidden existence...'.[2] For Proust, the so-called 'little things' – the taste of a small cake, the appearance of a hawthorn bush, a sudden stumble on an uneven paving stone – were pregnant with unsuspected significance. Each of these experiences triggered long-buried memories and, by disclosing an invisible, private realm of recollection and imagination, the familiar world was revealed in a new light: as a surface of appearances that conceals a deeper, subjective reality.

Such considerations are germane to an understanding of Tony Bevan's art. Since the early 1980s, Bevan has also found his ostensible subject matter in the everyday and the immediate. His imagery ranges from the human figure and self-portraits to corridors, buildings with rafters, the furniture in his studio and, more recently, trees and shelves containing mysterious files of information. Throughout, his response has never been limited to straightforward depiction. Rather, the capacity of these familiar things to yield unexpected associations, which his art then actively explores, has, for over thirty years, been a fertile field. Bevan began with photographs taken from newspapers and magazines, mainly images of the human figure. Such visual material would later also be used in conjunction with observation of his own appearance using either a mirror or photographs. Initially he also used other kinds of photographic material, notably American police identity records and un-posed images of defendants in law courts. From 1979 to 1984, Bevan and his partner the painter Glenys Johnson divided their time between London and New York. As cameras are permitted in United States courts, the resulting snapshots were an additional available source.

The large painting *The Prophet* 1982 belongs to that early phase. This enigmatic and disturbing image demonstrates that from the outset Bevan was not concerned with creating a literal appearance. Eschewing verisimilitude, the painting probes other, subjective areas of experience. *The Prophet* is a starkly confrontational painting, yet one tinged with an affecting vulnerability. A hand-cuffed youth is isolated within a surrounding black void. The figure is described almost in monochrome, an approach relieved only by the use of brilliant, acid yellow in the treatment of his shirt. Both hands are raised

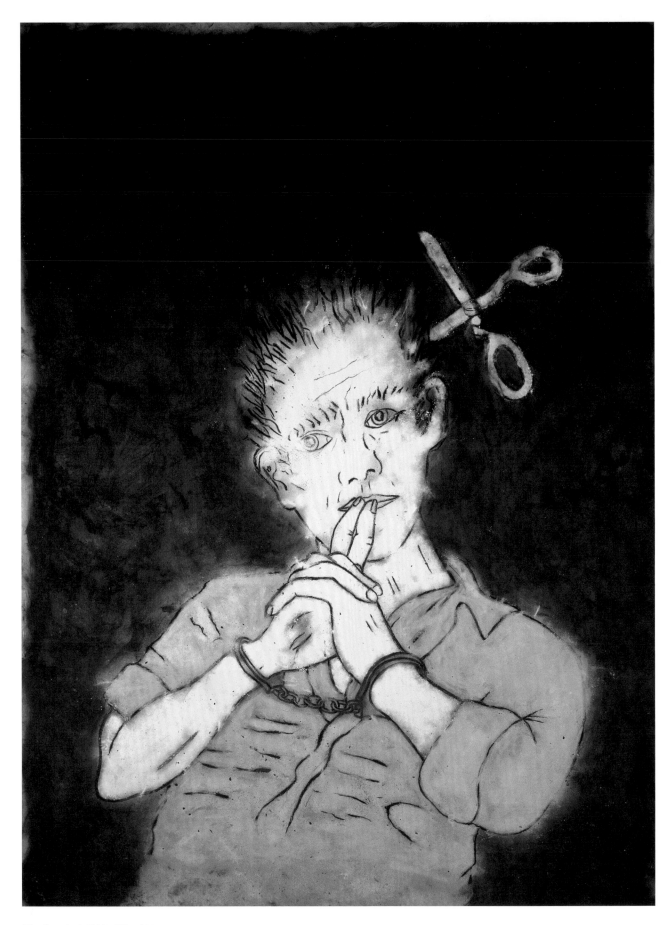

The Prophet, 1982, 432 × 314 cm

towards his face, the digits entwined, with both forefingers probing his lips. However, given his predicament, his facial expression is peculiar. Appearing thoughtful rather than pained, his demeanour seems strangely at odds with the painting's most alarming element: the blade of a pair of scissors embedded in the side of the boy's head.

The Prophet manifests several essential characteristics of Bevan's art. Notable among these are its roots in observation (whether derived from a photographic source, from life or from both combined); his inclusion of apparently ordinary subject matter; a tendency towards radical abstraction in the rendering of appearance; a pervasive ambiguity that frequently tips towards the enigmatic and the inexplicable; and, most important, the extreme transformation of understated and familiar imagery by elements that have an explicit imaginative source. In some cases, that transformation is connected with the process of abstraction itself which develops the image beyond its literal roots. In other instances – of which *The Prophet* is a prime example – the image acquires a compelling depth through the conjunction of seemingly ordinary things. The violence inflicted upon the boy who, nevertheless, seems strangely unconcerned, exercises a powerful, visceral fascination. The painting 'fixes the gaze', to use Bevan's own phrase.[3] But the irresistible nature of this image is not only visual. Its strangeness confronts reason and intimates a significance beyond rational explanation. This imperative – the compulsion to penetrate beneath the surface of 'little things', and to explore what Bevan has described as 'the imaginary spaces', the hidden reality, beneath everyday appearance – lies at the centre of his art and is its profound purpose.

These characteristics were developed further in other paintings made during the 1980s that were also based on found photographs. In *Exposed Arm* 1986 Bevan again depicted a youth. This time he

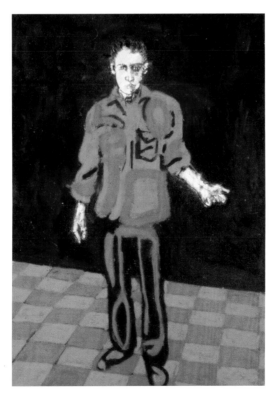

Exposed Arm, 1986, 222 × 156 cm

advanced beyond the half-length format of *The Prophet* and instead revealed an entire figure standing in an unspecified location signified by a chequered floor. As in the earlier painting, the subject's attitude is confrontational. He appears to stare directly ahead so that he connects with the viewer's own gaze. Proceeding beyond the summary description of detail in *The Prophet*, Bevan now employed an even greater degree of abstraction. Around 1980, he had abandoned his earlier use of gloss paint which gave his previous work a somewhat flat, emblematic character. From then on he used charcoal in combination with acrylic paint, so that drawing and painting were completely enmeshed. This way of working emphasised the physical, material nature of his materials, imparting texture and a strong graphic element, and he has employed it ever since. In *Exposed Arm*, the two media are united and the youth's appearance is conveyed in linear passages describing his features, wrist and hands, which are combined with broader areas of pigment overlaid with irregular shapes. Overall, the image is suffused with a dominant, intense red.

While these elements have – on the surface at least – an assertive character, the anonymous individual depicted nevertheless, again, appears defenceless. His outstretched arm and the upturned palm can be seen as a passive, even plaintive gesture. Contradicting any initial impression of aggression or defiance, the youth exposes a vulnerable area of the body. His attitude, psychology and the situation itself are deeply enigmatic. We are confronted with a human appearance, divorced from its original context, whose mysterious nature we are invited to contemplate. In such paintings Bevan began to inhabit an area that he would make uniquely his own. Working in response to a photograph – a fragment of the observed world – a subtle transformation has been effected. A motif has been abstracted from its original setting and, through the artist's subjective involvement, the context has

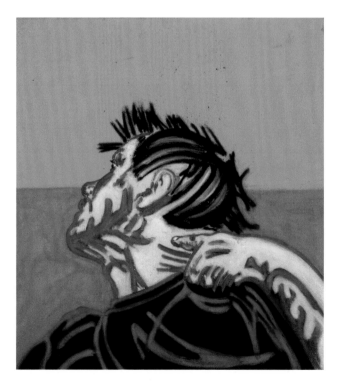

Self Portrait Neck, 1988, 222 × 156 cm

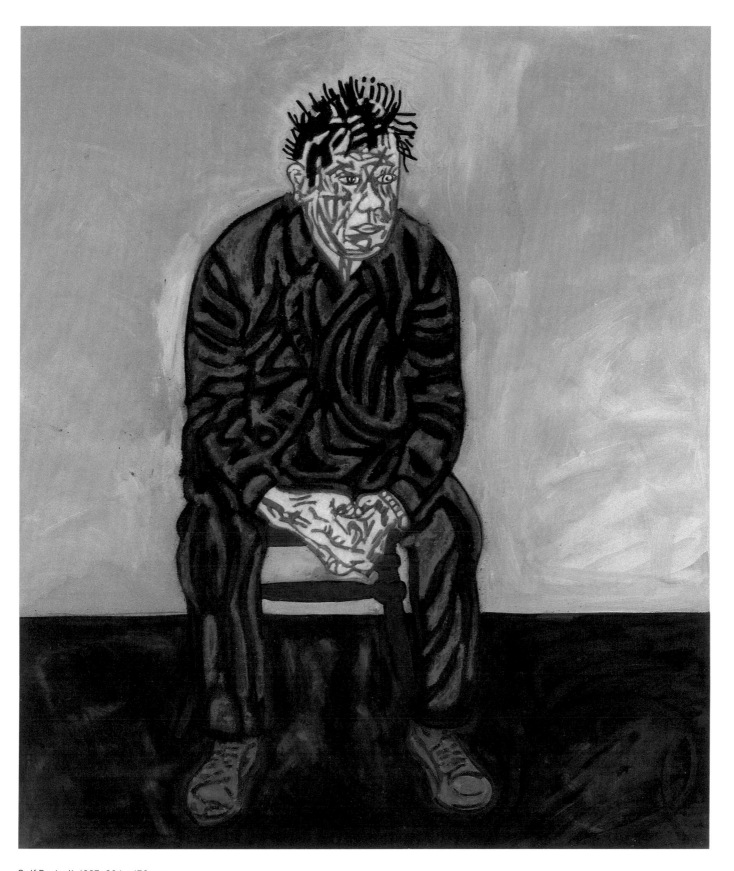

Self Portrait, 1987, 204 × 176 cm

been changed and its significance developed in new ways. As a result, the image appears strange and unsettling, as if revealing something that was previously hidden.

Bevan has spoken of his compulsion to 'put extra things in', a process of augmentation that is not simply connected with addition but, instead, transformation. Certain source images elicit a personal response that call for a deeper engagement in artistic terms. The reason why he is interested in certain motifs or situations is, for Bevan, essentially mysterious, as is the nature of the unexpected associations that are then provoked. The psychological mechanisms underpinning certain subjective responses are obscure, but Proust's reflections on such phenomena are illuminating. As the author pointed out, our visual experiences are intimately connected with the associations they produce: 'an image presented to us by life brings with it, in a single moment, sensations which are in fact multiple and heterogeneous.'[4]

For Proust, memory was complicit in these subjective resonances: 'a thing we have looked at in the past brings back to us, if we see it again, not only the eyes with which we looked at it but all the images with which at the time those eyes were filled.'[5] But as the writer intimated, recollection was only the beginning of a chain of associations. In a passage that is illuminating in considering Bevan's particular processes, Proust observed: 'this fantasy, if you transpose it into the domain of what is for each one of us the sole reality, the domain of his own sensibility, becomes the truth.'[6] Memory but also imagination are deeply implicated in the responses provoked by certain images and, as the novelist observed, that subjective involvement attains its own veracity. Although Bevan has never referred to Proust directly, the artist's own observations about his way of working place a similar premium on the involuntary nature of his personal responses to certain images. Unsure why particular things interest

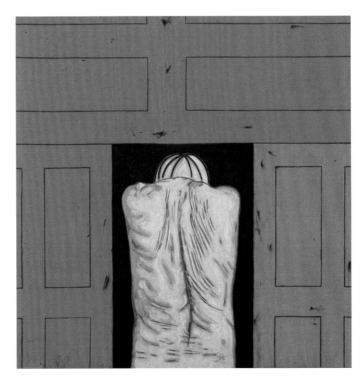

Self Portrait Back with Doors, 1990, 267 × 264 cm

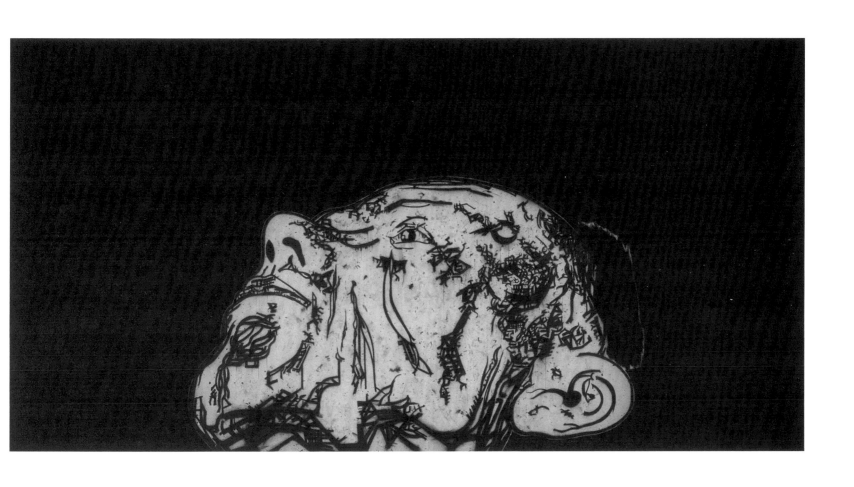

Head, 1996, 304 × 609 cm

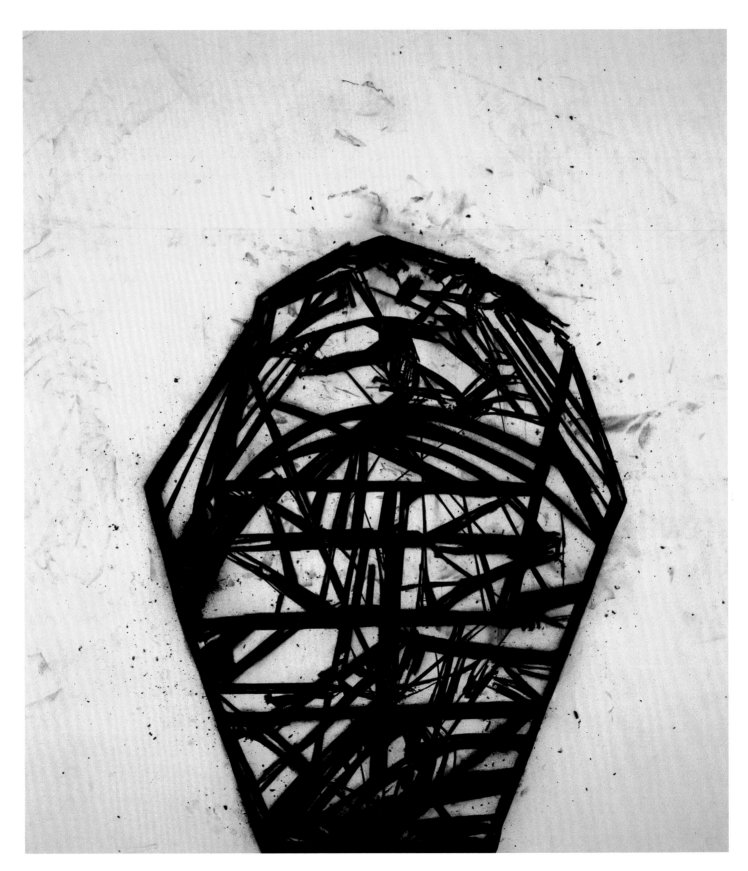

66 *Head and Neck*, 1999, 271 × 239 cm

him, and reluctant to explain the significance he attaches to them, Bevan is nevertheless unequivocal in one respect. 'Painting', he attests, 'is a thing of the mind.'

Given the deeply subjective, indeed psychological nature of that activity, it was perhaps natural that Bevan's work gravitated subsequently towards self-portraiture and to images of heads based on his own appearance. That said, the connection between the earlier paintings based on found images and the paintings that now ensued is striking. *Self Portrait* 1987 depicts the artist seated. A low background horizon introduces an element of ambiguity, it being uncertain whether the figure is positioned in front of the skirting board of a room or occupying some other, perhaps outdoor setting. As in the earlier paintings, the features and hands are areas of particular attention. Both have an expressive role but, again, the emotions conveyed are difficult to pin down. That inscrutability also extends to the figure's appearance. Although based on photographs and observation from life, the creation of a convincing likeness is evidently not Bevan's aim. Indeed, despite its title and source, the painting is striking for the degree to which it does *not* resemble the artist. The same may be said of *Self Portrait Neck* (PC885) 1988. This painting is one within a series that depicts the artist obliquely. His face is averted so as to expose with maximum emphasis his neck: that point of connection between the head and the torso and a vital site of transition. As with the exposed arm in the earlier painting, Bevan has focused on a vulnerable area of the body that, being traversed by arteries and veins, has a crucial role in sustaining life. To present the neck in this way has no counterpart in normal behaviour, and yet in the context of art Bevan presents it as the focus of attention.

Both these paintings were based on the artist's scrutiny of his own appearance, and in their different ways each takes that source image as a point of departure. In each case, his face has been

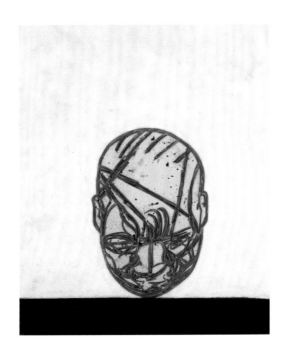

Head, 2004, 132 × 109 cm

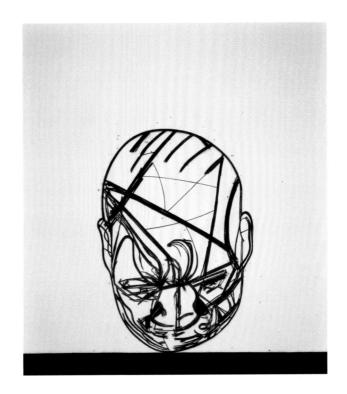

Head Horizon, 2010, 389 × 350 cm

transformed, covered by a network of red lines resembling exposed veins. The flesh seems stripped back, revealing the conduits of life that lie beneath its surface. The resulting sense of acute exposure is thus profoundly physical. But, at a deeper level, the paintings arrest the attention because of something even more raw. There is the sense of an imperative to penetrate beneath the surface: a will to wrest from frail flesh some deeper psychological significance. In that regard, the artist's subjective engagement with his own image has a dual role: that of cutting away an appearance – and then reconstructing it.

A PSYCHIC SPACE

The self-portraits were an important development for they demonstrated Bevan's gravitation towards images that functioned more explicitly as sites for psychological exploration. Going beyond the facts of literal description, his own body became, in Bevan's own words, 'a psychic space'. That observation, which can also be applied to his art more widely, can be viewed in different ways. On one level, his chosen motifs provide a context or armature. Each subject supplies a structure that sustains an involuntary engagement pursued through the process of drawing and painting. At the centre of that process, imagination has a crucial role and presence. But in viewing Bevan's paintings as 'psychic spaces', there is also a sense of the artist's compulsion to locate, identify and probe the mind *itself*: an intangible presence existing within a physical structure.

For the seventeenth century French philosopher Descartes, the operations of thought had a funda-

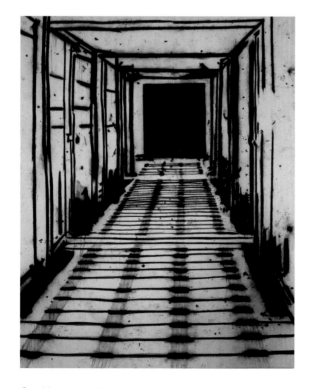

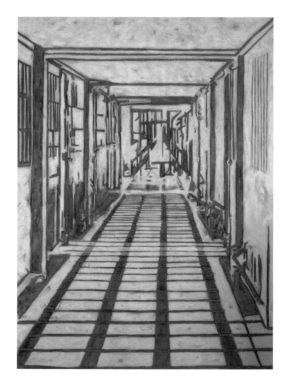

68 *Corridor*, 1995, 269 × 215 cm *Corridor*, 1995, 269 × 200 cm

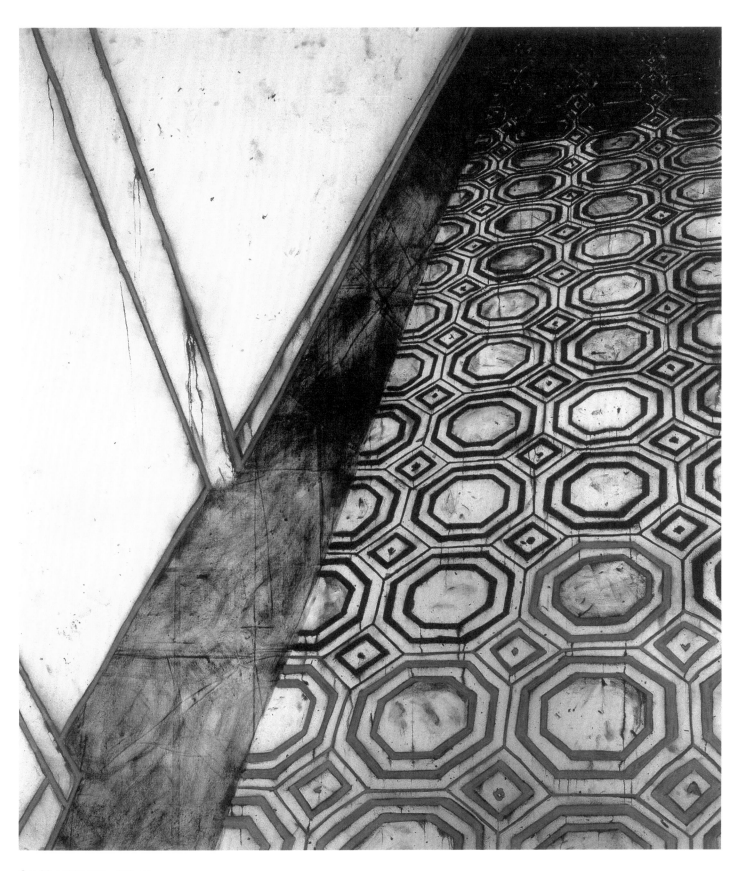

Corridor, 1995, 269 × 238 cm

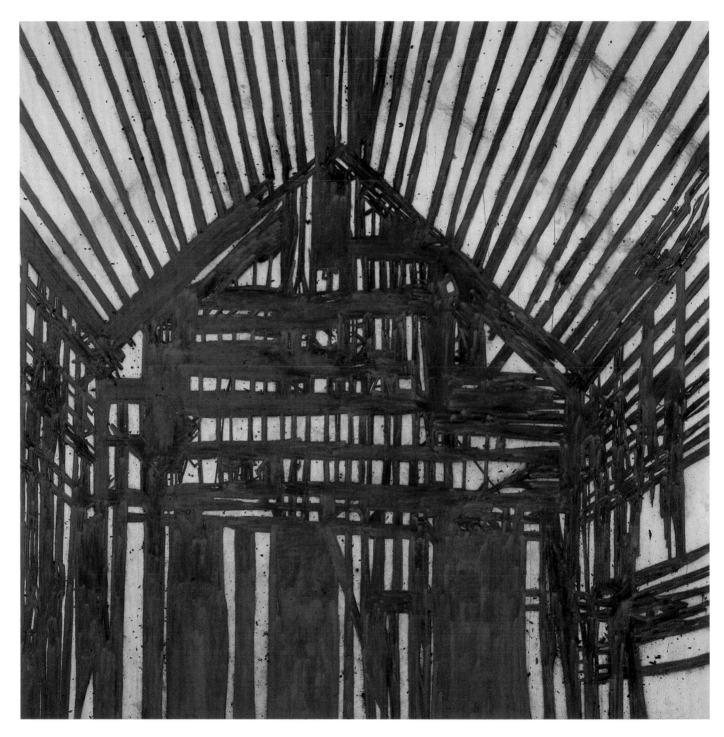

Red Interior, 1999, 212 × 218 cm

mental importance, providing what he identified as proof of his own existence. His famous dictum *Cogito Ergo Sum*, which translates as 'I think therefore I am', placed the mind at the centre of an individual's being. But the existence of cognition - the awareness of one's own thoughts and the experience of inhabiting, as it were, a mental space - posed questions which have vexed philosophers and scientists ever since. Modern day science equates the mind with the brain. But that equation in itself begs questions about how a physical organ can accommodate something as fugitive and immaterial as thought. The relation of mind and body remains a conundrum. Where is the mind located and how is it connected with the body? In considering Bevan's art as a whole, those questions, though unstated, seem ever-present. Viewed in this light, the blade that pierces the head of the boy in *The Prophet* has an unsettling significance, forming a violent thrust through the body towards the centre of consciousness.

From the mid-1980s, Bevan's depiction of the human body diversified, encompassing not only self-portraits but also images of a torso seen from behind and, in particular, an intense focus on the head seen in isolation. In his depiction of these particular motifs there is a sense of the artist contemplating the body, as if searching this physical structure for the mysterious, immaterial inhabitant that animates it. In *Self-Portrait Back with Doors* (PC 9026) 1990, the body is situated at a point of transition: a doorway. But, framed in this way, the torso becomes almost an obstruction, preventing passage to the space beyond. Traversed by lines that can be read both as wrinkles and as scars, the resistant materiality of flesh is asserted, its surface bearing the marks of experience. In the series of isolated heads which followed, Bevan continued to use his own appearance as a point of reference. But, as these progressively abstracted structures show, the resulting images developed far beyond their literal source.

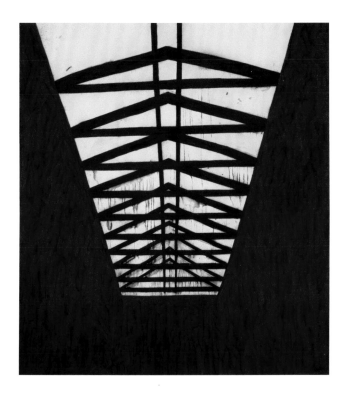

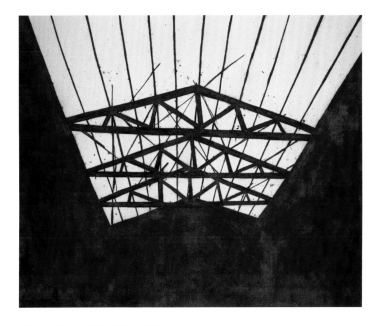

Violet Interior, 2003, 230 × 281 cm

Violet Interior, 2001, 274 × 251 cm

In *Head* (PC961) 1996, Bevan framed the uppermost part of the body, the container for thought, within the picture space. This device provides a powerful focus on the head's physical presence. But, because of the neck, a sense of connectedness to the body persists. In the later paintings, *Head* (PC046) 2004 and *Head Horizon* (PC102) 2010, the head exists alone, precariously balanced on a low horizon. Depicted in this way, the motif conveys an impression of detachment and isolation. Without scale or reference points there is a sense instead of a structure existing in an indeterminate space: a site or place that invites habitation. The imaginative elision of body and architecture is explicit in *Head and Neck* (PC992) 1999. In that painting, the visceral lines and marks have acquired a further significance. The head is presented less as a biological fact and, rather, as a strange, building-like structure.

In *Head Horizon*, the cranium has been opened up and the expressive linear activity exists within its confines. There is a sense of the artist's movements within the head, the lines being redolent of tracks or pathways. To that extent the image bears the traces of habitation. However, as a whole the motif is seen from outside, as if at a physical remove. This mode of representation is a unique characteristic of Bevan's images relating to the human figure. Whether depicting the entire body or the head alone, there is a curious sense of the strangeness of the thing depicted: its essential otherness. To some extent his work may be said to have an autoscopic character, relating to the experience of seeing oneself as if from *outside* the body.

In contrast, the corridors and built structures with rafters that date from the mid-1980s, convey an almost claustrophobic sense of being *inside* a structure. The experience conveyed is that of mental containment. Beginning with *Corridor* (PC9510) 1995, Bevan found a subject which, like his earlier use of the doorway motif, suggests a space for transition. Devoid of perspective, the visual experience

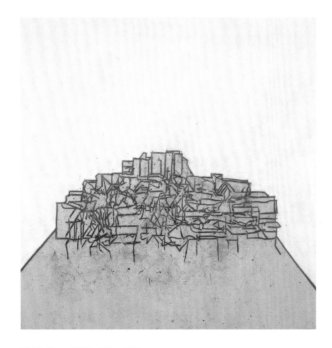

Table Top, 2005, 170 × 166 cm

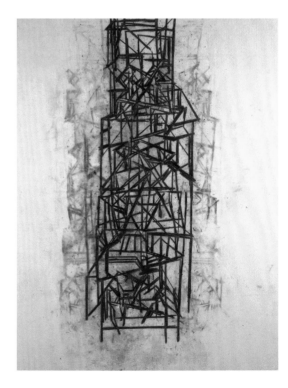

Studio Furniture, 2007 , 309 × 236 cm

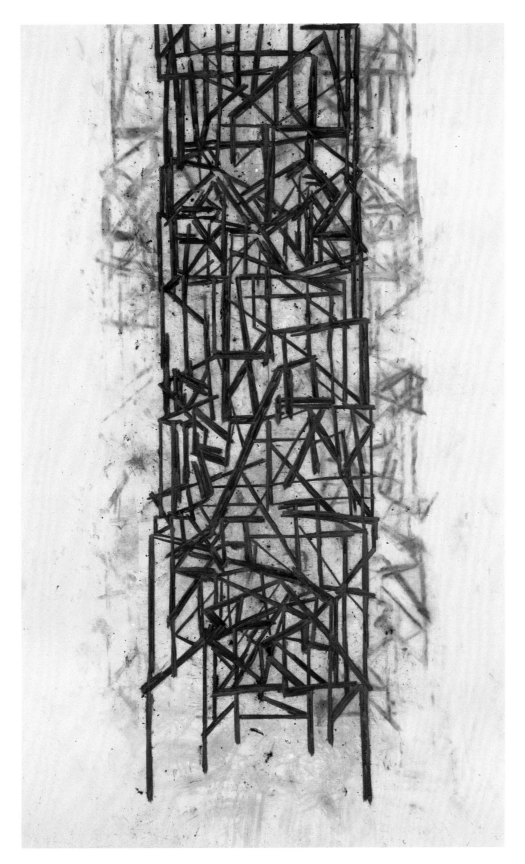

Studio Tower, 2008, 267 × 163 cm

is disorientating. We seem to be in an indefinable no-space, an enclosed interior leading to an unknown destination. Redolent of dreams, the passage seems as much psychological as physical. In the related *Corridor* paintings, for example *Corridor* (PC9514) 1995 and *Corridor* (PC9515) 1995, Bevan employed an intense single-point perspective that intensifies the feeling of confinement within a deeply recessive, windowless space. Unrelieved by external views, such structures are containers that heighten the impression of confinement and, as a result, an unsettling awareness of our own, thinking presence.

Red Interior (PC9922) 1999, and the later *Violet Interior* (PC0112) 2001 and *Violet Interior* (PC0310) 2003, present a fascinating modification of that experience. In these images, as before, the entire architectural structure encloses the field of vision. In a very immediate way the viewer experiences a feeling of being inside an enveloping – if fragile – structure. But in a surprising development the exterior world can be glimpsed from deep within the space, as if we are looking upwards and outwards. While Bevan's treatment of this subject is relatively understated, it is difficult to imagine a more acute evocation of personal experience: alone, existing inside a material frame, peering at the world outside.

In Bevan's recent paintings his exploration of interior experience has found an astonishing range of new motifs. Turning to the contents of his studio, the objects strewn on tables became fertile landscapes which characteristically underwent a long imaginative development. *Table Top* (PC0511) 2005 was a forerunner. In an echo of Proust's 'little things', it comprised deeply familiar objects. Yet, inhabited by the transforming power of imagination, a jumble of everyday items was revealed afresh. As if seen from afar, these mundane bits and pieces assumed the peculiar, labyrinthine architecture of an ancient hilltop town. In the successor paintings, *Studio Furniture* (PC0712) 2007, *Studio Tower*

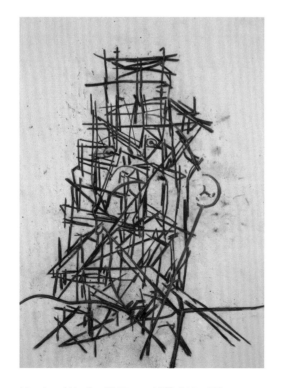

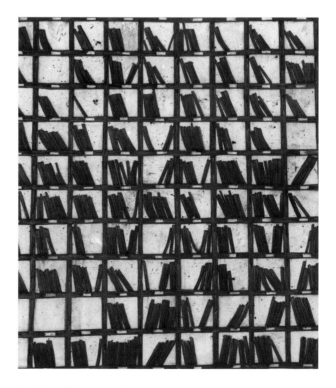

Head and Neck with Tower, 2009, 239 × 172 cm *Archive*, 2013, 158 × 140 cm

(PC081) 2008 and *Head and Neck with Tower* (PC093) 2009, that reconstructive process led in other, surprising directions. It generated fragile structures that combine architecture with fleeting intimations of the body.

In Bevan's series of paintings titled *Self-portrait after Messerschmidt*, and also the new *Tree* paintings, two very different motifs provide armatures for imaginative occupation. The first sequence of works relates to the expressive, psychologically charged 'character heads' made by the 18th century sculptor Franz Xaver Messerschmidt. Bevan's paintings reinterpret those earlier sculptures though an elision with his own distorted facial expressions. In apparent contrast, the *Tree* paintings were based on natural structures seen in China following visits made by the artist in 2007–8. Bevan's investigation of those botanical forms is nevertheless charged with a similar, if less explicit psychological significance. In an eerie revelation of nature's hidden structures, his depiction of the trees' dendritic growth echoes the brain's neural pathways. *Archive* (PC136) 2013 exemplifies a new, haunting subject. Based on a photograph, the painting resembles a shelf-structure containing secret files. It explores the idea of an enormous library of information. Like the mind, the nature, contents and limits of that enigmatic repository are unknown. In common with his art from its beginnings, these compelling works manifest the singular character of Bevan's contemplation of the material world – and its capacity to reveal, beneath the surface of the familiar, the ghosts of cognition.

Paul Moorhouse

1 First published in French, in
 seven volumes, 1913–1927
2 Marcel Proust, In Search of Lost
 Time, Volume VI, Time Regained,
 Vintage, London, 2000, p.253
3 This and all other statements by
 the artist are taken from a
 conversation between Tony
 Bevan and the author, 4 July 2014
4 Proust, p.245
5 Proust, p.241
6 Proust, p.241

CATALOGUE

Tree Study, 2008
Acrylic and charcoal on paper
44 × 71 cm
(PP081)

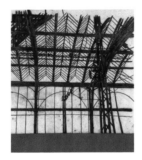

Red Interior, 2011
Acrylic and charcoal on canvas
274 × 242 cm
(PC114)

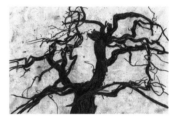

Tree No.1, 2011
Acrylic and charcoal on canvas
168 × 258 cm
(PC115)

Self Portrait The Smile, 2011
Acrylic and charcoal on canvas
147 × 132 cm
(PC118)

Self Portrait The Smile, 2011
Acrylic and charcoal on canvas
211 × 254 cm
(PC119)

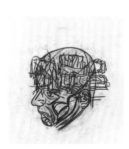

Head, 2011
Acrylic and charcoal on canvas
77 × 71 cm
(PC1114)

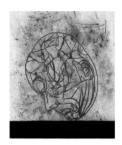

Self Portrait Head, 2011
Acrylic and charcoal on canvas
81 × 69 cm
(PC1116)

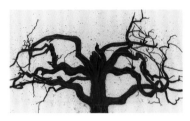

Tree No. 2, 2012
Acrylic and charcoal on canvas
239 × 331 cm
(PC121)

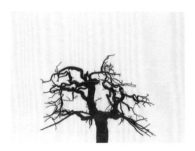

Tree No. 3, 2012
Acrylic and charcoal on canvas
137 × 232 cm
(PC122)

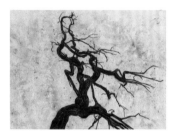

Tree No. 4, 2012
Acrylic and charcoal on canvas
173 × 237 cm
(PC123)

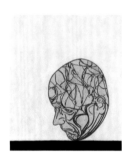

Self Portrait Head, 2012
Acrylic and charcoal on canvas
123 × 107 cm
(PC124)

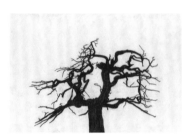

Untitled Tree No. 5, 2012
Acrylic and charcoal on canvas
168 × 248 cm
(PC125)

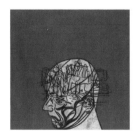

Self Portrait, 2012
Acrylic and charcoal on canvas
86 × 89 cm
(PC126)

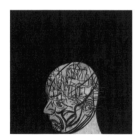

Self Portrait, 2012
Acrylic and charcoal on canvas
91 × 95 cm
(PC127)

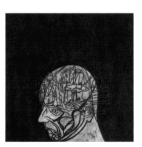

Self Portrait, 2012
Acrylic and charcoal on canvas
107 × 108 cm
(PC128)

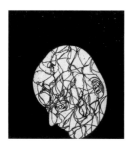

Self Portrait, 2012
Acrylic and charcoal on canvas
114 × 104 cm
(PC129)

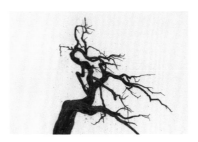

Tree No.7, 2012
Acrylic and charcoal on canvas
166 × 240 cm
(PC1210)

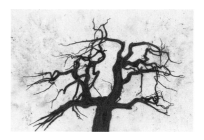

Tree No.6, 2012
Acrylic and charcoal on canvas
168 × 257 cm
(PC1211)

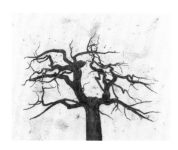

Tree No.8, 2012
Acrylic and charcoal on canvas
131 × 166 cm
(PC1212)

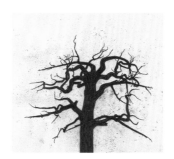

Tree No.9, 2012
Acrylic and charcoal on canvas
146 × 163 cm
(PC1213)

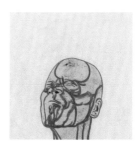

Self Portrait, 2012
Acrylic and charcoal on canvas
89 × 89 cm
(PC1214)

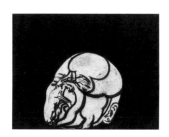

Self Portrait, 2012
Acrylic and charcoal on canvas
89 × 115 cm
(PC1215)

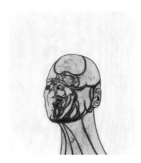

Self Portrait, 2012
Acrylic and charcoal on canvas
112 × 102 cm
(PC1216)

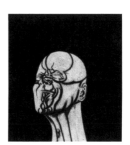

Self Portrait, 2012
Acrylic and charcoal on canvas
90 × 84 cm
(PC1217)

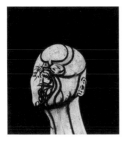

Self Portrait, 2012
Acrylic and charcoal on canvas
90 × 81 cm
(PC1218)

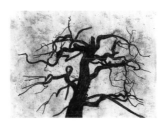

Tree (no.1), 2012
Acrylic and charcoal on paper
86 × 122 cm
(PP1219)

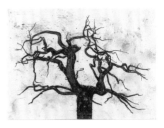

Tree (no.2), 2012
Acrylic and charcoal on paper
86 × 122 cm
(PP1220)

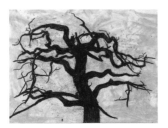

Tree (no.3), 2012
Acrylic and charcoal on paper
81 × 108 cm
(PP1221)

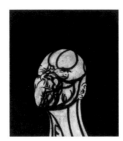

Self Portrait, 2013
Acrylic and charcoal on canvas
90 × 82 cm
(PC131)

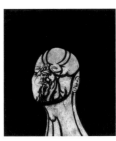

Self Portrait, 2013
Acrylic and charcoal on canvas
95 × 87 cm
(PC132)

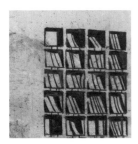

Archive, 2013
Acrylic and charcoal on canvas
47 × 46 cm
(PC133)

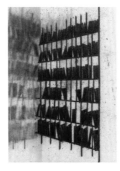

Archive, 2013
Acrylic and charcoal on canvas
109 × 80 cm
(PC134)

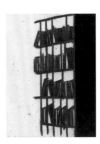

Untitled (Archive), 2013
Acrylic and charcoal on canvas
62 × 46 cm
(PC135)

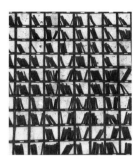

Archive, 2013
Acrylic and charcoal on canvas
158 × 140 cm
(PC136)

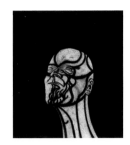

Self Portrait, 2013
Acrylic and charcoal on canvas
95 × 84 cm
(PC137)

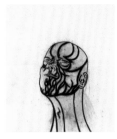

Self Portrait, 2013
Acrylic and charcoal on canvas
95 × 84 cm
(PC138)

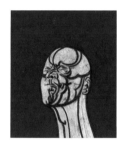

Self Portrait, 2013
Acrylic and charcoal on canvas
89 × 76 cm
(PC139)

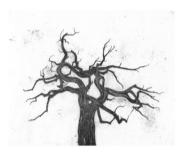

Tree No.10, 2013
Acrylic and charcoal on canvas
131 × 167 cm
(PC1310)

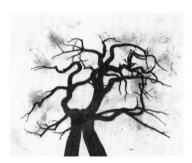

Tree No.11, 2013
Acrylic and charcoal on canvas
166 × 206 cm
(PC1311)

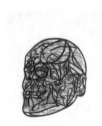

Self Portrait Skull, 2013
Acrylic and charcoal on canvas
45 × 39 cm
(PC1312)

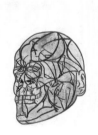

Self Portrait Skull, 2013
Acrylic and charcoal on canvas
90 × 86 cm
(PC1313)

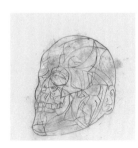

Self Portrait Skull, 2013
Acrylic and charcoal on canvas
89 × 90 cm
(PC1314)

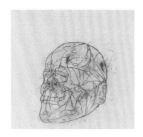

Self Portrait Skull, 2013
Acrylic and charcoal on canvas
60 × 63 cm
(PC1315)

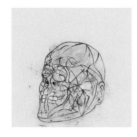

Self Portrait Skull, 2013
Acrylic and charcoal on canvas
60 × 63 cm
(PC1316)

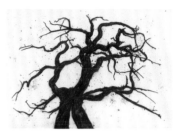

Tree (no. 4), 2013
Acrylic and charcoal on paper
86 × 122 cm
(PP1322)

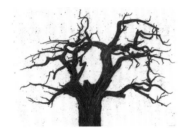

Tree (no. 5), 2013
Acrylic and charcoal on paper
86 × 122 cm
(PP1323)

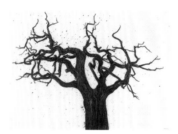

Tree (no. 6), 2013
Acrylic and charcoal on paper
86 × 122 cm
(PP1324)

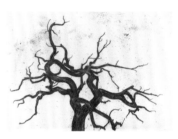

Tree (no. 7), 2013
Acrylic and charcoal on paper
86 × 122 cm
(PP1325)

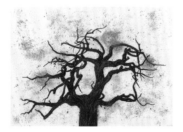

Tree (no. 8), 2013
Acrylic and charcoal on paper
86 × 122 cm
(PP1326)

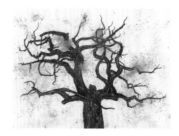

Tree (no. 9), 2013
Acrylic and charcoal on paper
86 × 122 cm
(PP1327)

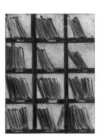

Archive, 2014
Acrylic and charcoal on canvas
69 × 53 cm
(PC141)

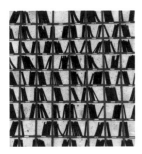

Archive, 2014
Acrylic and charcoal on canvas
164 × 157 cm
(PC142)

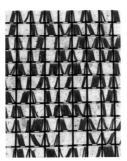

Archive, 2014
Acrylic and charcoal on canvas
192 × 155 cm
(PC144)

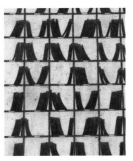

Archive, 2014
Acrylic and charcoal on canvas
194 × 166 cm
(PC145)

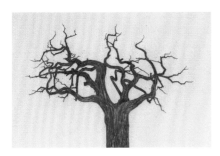

Tree No.12, 2014
Acrylic and charcoal on canvas
168 × 254 cm
(PC146)

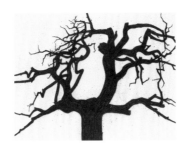

Tree No.13, 2014
Acrylic and charcoal on canvas
140 × 184 cm
(PC147)

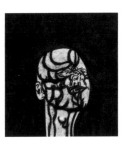

Self Portrait, 2014
Acrylic and charcoal on canvas
82 × 77 cm
(PC148)

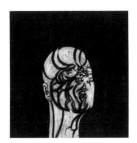

Self Portrait, 2014
Acrylic and charcoal on canvas
81 × 78 cm
(PC149)

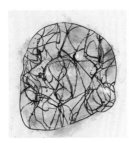

Self Portrait, 2014
Acrylic and charcoal on canvas
92 × 89 cm
(PC1410)

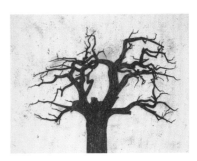

Tree No.14, 2014
Acrylic and charcoal on canvas
155 × 206 cm
(PC1411)

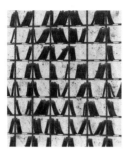

Archive, 2014
Acrylic and charcoal on canvas
185 × 161 cm
(PC1412)

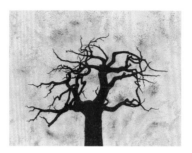

Tree No.15, 2014
Acrylic and charcoal on canvas
163 × 212 cm
(PC1413)

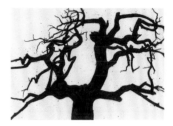

Tree (no.13), 2014
Acrylic and charcoal on paper
86 × 122 cm
(PP1428)

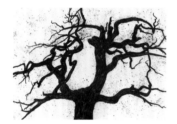

Tree (no.1), 2014
Acrylic and charcoal on paper
86 × 122 cm
(PP1429)

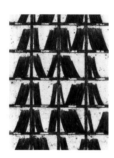

Archive, 2014
Acrylic and charcoal on paper
103 × 78 cm
(PP1430)

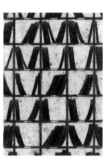

Archive, 2014
Acrylic and charcoal on paper
122 × 86 cm
(PP1431)

TONY BEVAN

Born in Bradford, 1951
Lives and works in London

EDUCATION

1968–1971
Bradford School of Art, Bradford
1971–1974
Goldsmiths College, London
1974–1976
Slade School of Fine Art, London

SELECTED SOLO EXHIBITIONS

2014
Trees and Archives, Ben Brown Fine Arts, London

2013
Chinese Trees, Ben Brown Fine Arts, Hong Kong
Recent Paintings, Niagara Galleries, Melbourne
Recent Paintings, Liverpool Street Gallery, Sydney

2012
LA Louver Gallery, Los Angeles, CA

2011
Self-Portraits, National Portrait Gallery, London
Ben Brown Fine Arts, London
Ben Brown Fine Arts, Hong Kong

2010
Painting Installation, De La Warr Pavillion, Bexhill
Recent Paintings, Galerie Vidal Saint Phalle, Paris

2009
Construct, James Hyman Gallery, London
Recent Paintings and Works on Paper, Michel Soskine Inc., Madrid

2008
New Paintings, Ben Brown Fine Arts, London

2007
Monotypes, Marlborough Fine Art, London
LA Louver, Venice, CA
Paintings 1982–2007, Centre d'Art Contemporain, Perpignan

2006
Table Top Paintings, Galerie Vidal-Saint Phalle, Paris
Paintings and Works on Paper 1982–2005, Liverpool Street Gallery, Sydney

Paintings 1987–2005, Turnpike Gallery, Leigh
Paintings, Ben Brown Fine Arts, London

2005
Paintings 1994–2005, Michel Soskine Inc., Madrid
A Retrospective Exhibition at Institut Valencia d'Art Modern (IVAM), Valencia

2004
Paintings and Drawings, Liverpool Street Gallery, Sydney; Niagara Galleries, Melbourne
Drawings, Albion Gallery, London

2003
Recent Work, Galerie Vidal-Saint Phalle, Paris
Works on Paper, The Israel Museum, Jerusalem
Paintings 2000–2003, Michael Hue-Williams Fine Art, London
Works from Deptford, Paintings and Drawings 1982–2002, Abbot Hall Art Gallery, Kendal
Milton Keynes Gallery, Milton Keynes
Recent Paintings, Galerie Wittenbrink, Munich

2002
Paintings and Drawings, Robert Miller Gallery, New York, NY
Drawings, Michael Hue-Williams Fine Art, London
The Complete Prints, James Hyman Fine Art, London

2000
Michael Hue-Williams Fine Art, London

1999
Paintings, Abbot Hall Art Gallery, Kendal
Paintings and Drawings, LA Louver, Venice, CA
Neue Bilder, Galerie Wittenbrink, Munich

1998
Michael Hue-Williams Fine Art, London
Drawings and Paintings on Paper, Matt's Gallery, London

1997

Paintings of the 80s and 90s, Brandenburgische Kunstsammlungen, Cottbus

1996

Neue Bilder, Galerie Wittenbrink, Munich
Matt's Gallery, London
Theo Waddington Fine Art, London

1995

Kopf Bilder, Galerie Wittenbrink, Munich
Recent Paintings, LA Louver, Venice, CA

1993

New Paintings and Prints, Galerie Wittenbrink, Munich
Drawings, Frith Street Gallery, London
Whitechapel Art Gallery, London
The Meeting and Related Works, Louver Gallery, New York, NY

1992

The Meeting and Other Recent Paintings, LA Louver, Venice, CA

1991

Louver Gallery, New York, NY
Galerie Elke Zink, Baden-Baden

1990

Neue Bilder, Galerie Wittenbrink, Munich
Kunstverein Lingen, Lingen

1989

Paintings, LA Louver, Venice, CA
Staatsgalerie Moderner Kunst Haus der Kunst, Munich

1988

Galerie Wittenbrink, Munich
Neue Bilder, Kunsthalle zu Kiel, Kiel
Ronald Feldman Gallery, New York, NY

1987

Painting 1980–87, ICA, London; Orchard, Derry; Kettle's Yard, Cambridge; Cartwright Hall, Bradford

1986

Matt's Gallery, London
Neue Bilder, Galerie Wittenbrink, Munich

1985

The Honest Portrait, National Portrait Gallery, London
Emblems, Riverside Studios, London

1984

Chapter Arts Centre, Cardiff
Bilder, Galerie Wittenbrink, Regensburg

1983

Portraits and Emblems, Galeria Akumulatory 2, Poznan

1982

Matt's Gallery, London

1981

Matt's Gallery, London

1976

Robert Self Gallery, London
Caius College Gallery, Cambridge

SELECTED GROUP EXHIBTIONS

2012

Messerschmidt and Modernity, The J. Paul Getty Museum, Los Angeles, CA
Max Neumann – Tony Bevan – Martin Assig, Galerie Vidal-Saint Phalle, Paris

2011

Loose Canon, LA Louver, Los Angeles, CA
Figuration, LA Louver Gallery, Los Angeles, CA

2010

Summer Exhibition 2010, Royal Academy of Arts, London
Able Bodied, Donna Beame Fine Art Gallery, University of Nevada, Las Vegas, NV
Interior Spaces, Eagle Gallery, London

2009

Summer Exhibition 2009, Royal Academy of Arts, London
Paint Made Flesh, Frist Center for the Visual Arts, Nashville, TN
The Philips Collection, Washington, DC
Memorial Art Gallery, Rochester, NY

2008

Summer Exhibition 2008, Royal Academy of Arts, London
Building Bridges, Today Art Museum, Beijing
Group Exhibition, Michel Soskine Inc., Madrid
Miradas Arquitectónicas en la Colección del IVAM, Valencia

2007

Summer Exhibition 2007, Royal Academy of Arts, London
Then and Now, James Hyman Gallery, London

2006

Motion on Paper, Ben Brown Fine Arts, London
Drawing Inspiration, Contemporary Drawings, Abbot Hall Art Gallery, Kendal
Portraits, James Hyman Fine Art, London

2005

A Visages Decouverts, Le 10 Neuf, Centre Regional d'Art Contemporain, Montbeliard

2004

Multiple Selves, James Hyman Fine Art, London

2003

A Century of British Drawings, James Hyman Fine Art, London
From Life Radical Figurative Art from Sickert to Bevan, James Hyman Fine Art, London

2002

Five Painters, Kilkenny Arts Festival, Kilkenny

2000

Painting, I Love, Michael Hue-Williams Fine Art, London
Look Out: Art, Society, Politics, Wolverhampton Art Gallery, Wolverhampton; Bluecoat Gallery, Liverpool; Wolsey Art Gallery, Ipswich

1999

Bacon, Bevan, Guston and Baselitz, Michael Hue-Williams Fine Art, London
The School of London: From Bacon to Bevan, Musee Maillol, Paris; Auditorio de Galicia, Santiago de Compostela; Kunsthaus Wien, Vienna

1998

Last Dreams of the Millennium – The Reemergence of British Romantic Painting, Stephen Solovy Art Foundation; California State University, Long Beach, CA; Tyler Museum of Art, Tyler, TX; Manoa Art Gallery, University of Hawaii, Honolulu

1996

Masculine Measure, Michael Kohler Arts Centre, Sheboygan, WI

1995

Inside Out, Aldrich Museum of Contemporary Art, Ridgefield, CT; Galeria Arialdo Ceribelli, Bergamo

1994

Here and Now: Painting since 1970, Serpentine Gallery, London

1993

The Portrait Now, National Portrait Gallery, London

1992

British Figurative Painting of the XX Century, The Israel Museum, Jerusalem

1991

Out of Limbo, Foundacion Luis Cernuda, Seville
Five Painters from London, Colegio de Arquitectos, Malaga

1990

Inconsolable, Louver Gallery, New York, NY
Picturing People: Figurative Art in Britain 1945–84, National Gallery, Kuala Lumpur; Museum of Art, Hong Kong; National Gallery, Harare

1989

Prospect 89, Schirn Kunsthalle, Frankfurt

1988

European Painting and Sculpture, LA Louver, Venice, CA
Contemporary Portraits, Flowers East, London
Aperto 88, XLIII Biennale di Venezia, Venice
The British Picture, LA Louver, Venice, CA

1986

Human Interest, Manchester Arts Centre, Manchester
Otherland, Ronald Feldman Gallery, New York, NY
Hand Signals, Ikon Gallery, Birmingham

1984

Off Shore, Kunstlewerkstatt, Munich; Stadtische Galerie, Regensburg
Problems of Picturing, Serpentine Gallery, London
Private Symbol, Social Metaphor, Sydney Bienniale, Sydney
4 Artists, Bluecoat Gallery, Liverpool

1982

Before It Hits The Floor, ICA, London

1970

New Directions in Printmaking, South London Art Gallery, London

AWARDS AND HONOURS

2007
Elected Royal Academician of the Royal Academy of Arts, London

PUBLIC COLLECTIONS

Abbot Hall Art Gallery, Kendal
Arts Council, London
Bayerische Staatsgemaldesammlung, Munich
Birmingham Museum of Art, Birmingham
British Council, London
British Museum, London
Castle Museum, Nottingham
Churchill College, Cambridge
Contemporary Arts Society, London
Greater London Arts Association, London
Institut Valencià d'Art Modern, Valencia
Israel Museum, Jerusalem
John Creasey Collection, Salisbury
Kunsthalle Kiel, Kiel
Leeds City Art Gallery, Leeds
Long Museum, Shanghai
Louisiana Museum, Humlebaek
Metropolitan Museum of Art, New York, NY
Modern Art Museum, Stockholm
Museum of Contemporary Art, Los Angeles, CA
Museum of Modern Art, New York, NY
National Portrait Gallery, London
Open University, Milton Keynes
Palm Springs Desert Museum, Palm Springs, CA
Pinakothek der Moderne, Munich
Royal Academy Collection, London
Swindon Museum and Art Gallery, Swindon
Tate Gallery, London
Theo Wormland Stiftung, Munich
Toledo Museum of Art, Toledo, OH
Whitworth Art Gallery, Manchester
Wolverhampton Art Gallery, Wolverhampton
Wurth Museum, La Rioja
Yale University Art Gallery, New Haven, CT

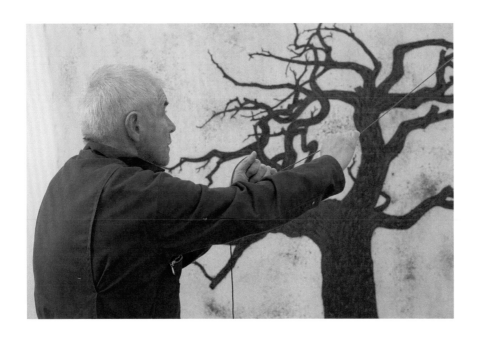

Published on the occasion
of the exhibition

TONY BEVAN
TREES AND ARCHIVES
26 November 2014 – 3 January 2015
at Ben Brown Fine Arts, London

BEN BROWN FINE ARTS
LONDON
12 Brook's Mews, London W1K 4DG
& 52 Brook's Mews, London W1K 4EE
T +44 (0)20 7734 8888
F +44 (0)20 7734 8892
info@benbrownfinearts.com
www.benbrownfinearts.com

BEN BROWN FINE ARTS
HONG KONG
301 Pedder Building, 12 Pedder Street
Central Hong Kong
T +852 2522 9600
F +852 2526 9081
hkinfo@benbrownfinearts.com
www.benbrownfinearts.com

Every effort has been made to contact
the copyright-holders of photographs.
Any copyright-holders we have been
unable to reach or to whom inaccurate
acknowledgement has been made are
invited to contact the publisher.

Catalogue design and production
by Peter B. Willberg

Printed by Printmanagement Plitt GmbH,
Oberhausen

ISBN 978-0-9574670-2-6